smart phone
smart photo editing

smart phone smart photo editing

A complete workflow for editing on any phone or tablet using Snapseed

Jo Bradford

CICO BOOKS
LONDON NEW YORK

For Kade and Grace
So glad I made such photogenic children and that you still smile for my camera.

Published in 2021 by CICO Books
An imprint of Ryland Peters & Small Ltd
20–21 Jockey's Fields 341 E 116th St
London WC1R 4BW New York, NY 10029

www.rylandpeters.com

10 9 8 7 6 5 4 3 2 1

A CIP catalog record for this book is available from the Library of Congress and the British Library.

ISBN: 978-1-80065-053-4

Printed in China

Editor Caroline West
Design concept Paul Tilby

In-house designer Paul Stradling
Art director Sally Powell
Head of production Patricia Harrington
Publishing manager Penny Craig
Publisher Cindy Richards

MIX
Paper from responsible sources
FSC® C106563
FSC www.fsc.org

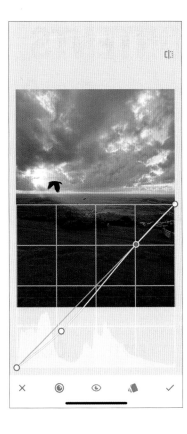

CONTENTS

FOREWORD

A few years ago, I wrote a book about smart phone photography and to this day I have been very pleasantly surprised at how well it has been received. Since that first book came out, I have frequently been asked about workflows and skills for editing all those lovely photos that everyone learned to take after reading *Smart Phone Smart Photography*. And so, it occurred to me that I had only really covered half of the story of what makes a photo "great" in my first book, as it perhaps didn't delve into photo editing in enough depth.

This led me to write a course about smart phone photo editing, which has become very popular since its inception. I decided to use Snapseed as the editing app because it can be used on Android and Apple smartphones, also tablets, and best of all, it is free to everyone. It bears mentioning here that it was also chosen because it is an extremely powerful app. I love the fact that Snapseed is all about non-destructive editing—you can work on your edits as layers and be flexible and experimental in your editing, safe in the knowledge that everything you do can be undone if it doesn't work.

Having grown up with analogue photography, I always understood the actual taking of the picture to be only the first part of the photographic process. The film would then have to be removed from the camera, taken into a darkroom and processed further to create a final print. Nowadays, with digital shooting, we don't need a darkroom any more. But we can, and often should, use editing tools to enhance our pictures and create perfect images that look just the way we wanted them to when we captured them. We can even create

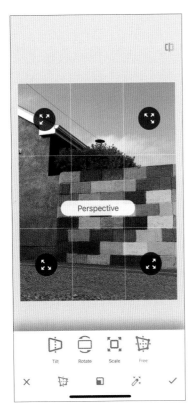

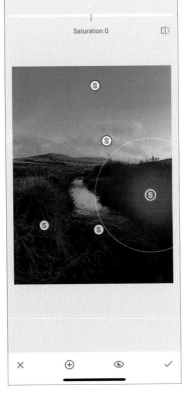

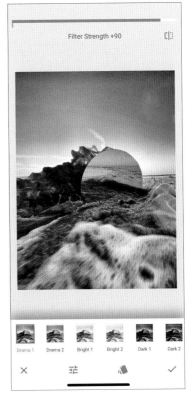

BEFORE

AFTER

images that look like something completely out of this world, made by combining multiple images to make composite images.

All these things are super-easy to do with Snapseed. In this book, I wanted to share with you not just the skills for editing using the app, but also some of the more interesting things that you can do too. Taken step by step, the order the tips appear in form a kind of workflow, which is something that many people want to understand more. Once you have this skillset down, then it is up to you to interpret how to use these skills to suit your own style of working. For example, there are many different ways you could composite two images together using the Double Exposure tool (see page 104) to create a wealth of other more interesting images. I'd like to think that using this book will encourage you to think differently about the way you take photos too, making you work

with potential beyond the realm of the shutter-click. After reading this book you'll know so much more about what you can achieve with your images in the editing stage.

Carry on reading to discover and harness amazing new skills. A word of caution though: just because you can apply every stage of an editing workflow to an image, that doesn't mean you should. Remember the motto made famous by Josef Albers that I always use as my rule of thumb when it comes to editing: "Do less in order to do more."

I hope you enjoy your creative editing journey.

Jo

CHAPTER 1
INTRODUCING SNAPSEED

ABOUT SNAPSEED

Snapseed is one of the most popular and versatile photo-editing apps in the iTunes and Google Play app stores, and it is certainly one of my favorites. Originally developed by Nik Software, Snapseed was acquired by Google back in 2012, which means that Snapseed has been around for a long time in terms of smart-phone apps. Under Google's stewardship Snapseed has been redesigned and updated, turning it into a powerful app with some impressive features for android and Apple devices. It also works brilliantly with the Apple iPad and Apple Pencil combination if you want more precision in your edits.

Whether you are using your fingers or a stylus pen, you will be able to fine-tune your edits precisely. You will quickly find that using your fingers to stroke and pinch directly on the screen you're looking at becomes highly intuitive, and you will perhaps wonder how you ever managed to be so precise with your edits using a mouse on a desk while looking at a screen elsewhere.

UNDO AND RE-DO YOUR EDITS

One of the most appealing things about Snapseed is that you can feel free to play and have fun with it. Nothing is set in stone and you can't make a mess that you won't be able to fix. Snapseed is all about non-destructive editing—you can work on your edits in layers which are added to the file in sequence and don't replace earlier ones. This gives you the flexibility to work freely and experiment with various features, knowing that each edit you make is not irreversible, as is often the case with editing apps.

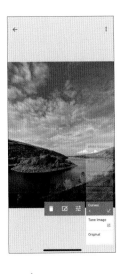

EDITING WORKFLOW

Establishing a workflow to edit your photographs efficiently will ensure you end up with a beautifully crafted image that is created in the least time possible. Everyone has their own way of working that suits their needs, but the following is the workflow I prefer to use in my own editing:

STAGE 1 Assessment of the image to decide what needs to be done (see page 19).

STAGE 2 RAW development of the image (see pages 20–21)
Once assessment is made, if you have shot a RAW file (as opposed to a JPEG or TIFF) begin with the RAW development tools (see pages 20–21). For editing other file formats go straight to the compositional section on page 22. If you're unsure whether you are shooting RAW files or not, please refer to the RAW development content (page 20).

STAGE 3 Global adjustments of the image (see pages 36–67)
These are edits that are made to the entire area of an image. They include adjustments to exposure, color, and contrast.

STAGE 4 Local adjustments of the image (see pages 68–79)
These more selective tools allow you to isolate and adjust specific or local areas of your image.

SELECTING IMAGES FOR EDITING

Before you begin editing the photographs from any shoot, you first need to identify which images you would like to work with. You can do this by using three basic stages, or "passes."

FIRST PASS

You can easily discount photos that are out of focus or where the composition just doesn't work. Instinctively disregard anything that doesn't feel comfortable to view. At this stage, you should rate the images by marking them with a star or heart and highlight only those images that especially appeal to you. Put all your chosen images in a Favorites album.

SECOND PASS

When you open your Favorites album, you should see all the images you starred or hearted in the first pass. Go through these images again. If you selected multiple photos of the same or a similar thing, then keep two or three of these and un-star or un-heart the rest.

THIRD PASS

Look through your now reduced Favorites album again. Pay even closer attention to things such as focus. Ask yourself questions such as: "Which image is sharpest and best composed?" Cut out any duplicates, so you just have one of each image or similar images.

CHAPTER 2
FIRST STEPS

First things first, let's get familiar with the interface, which is the way you will interact with the Snapseed software. Then look at assessing an image, which is the first stage of any edit. And if you are interested in shooting RAW, everything you need to know about RAW developing in Snapseed is also covered here.

OPEN AN IMAGE

1 Tap the (**+**) sign to open an image. A pop-up menu will appear.

2 The most recent images are shown in a ribbon. Swipe through these recent images and select one of those. Alternatively, select **Open from Device** to choose an image from your photo albums on the device.

THE USER INTERFACE (AKA THE HOME SCREEN)

Let's begin by becoming more familiar with the Home screen. This is the first screen you see when Snapseed opens an image, and there are various icons across the top and bottom that you can interact with.

The user interface may look slightly different on tablets to the images in this book, which show Snapseed being used on a smart phone. This is also the case for the individual Tools as they are opened. One of the main differences is that menus may appear down the right-hand side of the image rather than below it. Irrespective of how the app displays, the functionality remains the same. The icons you see across the top and bottom of the screen are shown in the images below and on the next page:

OPEN See page 14 for more on how to Open an Image.

EDIT HISTORY/LAYERS STACK See pages 55–56 for more on Layers.

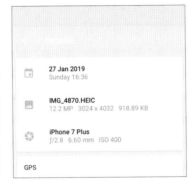

27 Jan 2019
Sunday 16:36

IMG_4870.HEIC
12.2 MP 3024 x 4032 918.89 KB

iPhone 7 Plus
f/2.8 6.60 mm ISO 400

GPS

INFORMATION This takes you to the **Details** area, which includes four different pieces of information:

1 Time Stamp Information provides the date, day, and time the picture was taken.

2 Image File Information begins with the filename—in this example, IMG_4870.HEIC. The file format is indicated after the dot (period/full-stop)—for example, .jpeg or .HEIC. Below this line is information on the size of the image in megapixels (here 12.2 MP). This is followed by the pixel dimensions (here 3024 x 4032) and the file size in megabytes (on an Android device) or kilobytes (on an Apple iOS device). In the example shown here, this is 918.89 KB.

3 Camera Information is a record of how the image was shot, including the aperture the image was shot at (here f/2.8), the lens/focal length (here 6.60mm), and, finally, the ISO (ISO 400 in this example). The Aperture is the size of the hole that opens to let the light in when the shutter is pressed. You can alter the sensitivity of the sensor to let more or less light in when the shutter opens depending on how bright the shooting conditions are. This sliding scale is referred to as the ISO value.

4 GPS Information If the location settings/GPS coordinates are enabled on the camera at the time of image capture, the **GPS Information** will be shown in the form of a scalable map.

PREFERENCES Selecting the Three-Dots icon in the top right of the screen enables you to access Preference functionality.

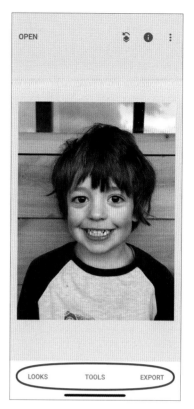

You can then select **Tutorials** and **Help & feedback** or choose **Settings** for options and preferences for **Saving**, **Exporting**, and **Sharing**.

Setting the **Image sizing** options for exporting and sharing images to **Do not resize** and the **Format and quality** to **JPG 100%** means the image won't be compressed or saved as a smaller file, which would affect the quality. Saving to 100% ensures maximum quality for output to screen and print.

LOOKS/TOOLS/EXPORT The options in the white panel at the bottom of the screen are **Looks** on Apple iOS devices (or **Styles** on Android devices), **Tools**, and **Export**.

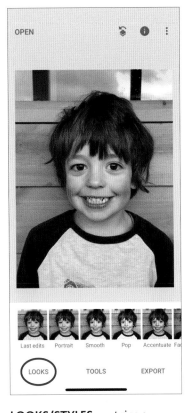

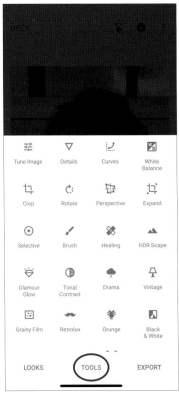

LOOKS/STYLES contains a collection of pre-set filter overlays that produce different visual effects and styles. Any one of these can be applied to an image with a single tap. This is discussed in more detail on page 60.

TOOLS Opening this menu reveals a vast array of Tools that will be covered in more detail throughout the book.

EXPORT Unsurprisingly, this gives you the Saving, Sharing, and Export options, which are explored in more detail later in the book (see page 34).

You can zoom in to see details of an image by making a pinching gesture on the screen. Pinching out will zoom in and pinching in will zoom out. Once you have zoomed in, use two fingers or drag the little blue rectangle that appears in the navigation window at the bottom of the screen to pan around the image (see **Clean Up**, Step 2 on page 32 to see how this window appears).

ASSESSING AN IMAGE

The first stage of any photo-editing process is to assess the image and decide what needs to change about it. The following shows the first stage of my usual workflow routine:

• **Image composition** Look for any basic compositional issues that affect the horizontal lines such as wonky horizons.

• **Cropping** Decide whether cropping the image to reframe it will make the composition stronger. Also identify any perspective issues such as leaning buildings.

• **Verticals** Identify issues with converging verticals, such as buildings or trees appearing to lean toward each other at the top of the frame.

• **Spot flaws** Look at any distractions and flaws such as color spots, footprints, and blotches that can be cleaned out to improve the image.

• **Fine-tuning** Give some thought to any adjustments that need to be made to the color, light and shade, and details.

RAW DEVELOPING

RAW files are sometimes known as digital negatives, so can have the suffix .raw or .dng. RAW files store the original sensor data before it becomes an actual image, so they have a lot more scope for editing. RAW Developing in Snapseed provides photographers with a much higher degree of control over their images. This is of particular concern to those interested in print output as the final destination of their photos. The alternative to RAW files is JPEGs (identifiable by the suffix .jpg). which are smaller, compressed files created at the cost of some information. JPEG files are best for images that need to be small enough to load quickly on websites, and will mainly be viewed on screens.

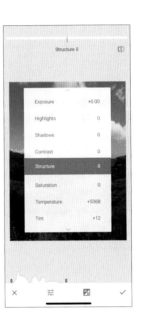

1 **Raw Develop** mode will automatically launch when a RAW file is opened in Snapseed, and it opens in **Exposure** mode. This can be revisited at any time by accessing the **Tools** menu or the **Layers** stack under **Edit History** (see pages 51–54).

2 At the bottom left of the screen is a histogram which gives information on the image exposure. A histogram is a basic graph that shows the distribution and range of tones in an image, from pure black shadows (the zero at the left-hand side) to pure white highlights (the zero at the right-hand side). See page 43 for more on histograms.

3 Slide a finger vertically on the phone or select the **Slider** icon at the bottom of the screen to reveal the main RAW Develop options menu:
Exposure adjusts the amount of light and brightness in the image.
Highlights adjusts only the brightest areas of the image.
Shadows adjusts only the darkest areas of the image.
Contrast adjusts the degree of difference between shadows and highlights.
Structure adjusts the texture of the details in the image without affecting the hard edges of the objects in the image.
Saturation adjusts the vibrancy and intensity of the colors and hues in the image.
Temperature adjusts the color temperature by shifting the hues toward cool blue tones or warm yellow tones.
Tint adjusts the colors across the range of the green and magenta hues in the image.

4 In the **White Balance** menu choose **As shot** to see the original image. Other pre-set light temperature options available there include **Autobalance, Sunny,** and **Cloudy.**

5 Slide the menu ribbon over at the bottom of the screen to reveal more **White Balance** options such as **Shade, Tungsten, Fluorescent,** and **Flash.**

6 Selecting the **Color Picker** tool reveals a magnifying loupe with crosshairs. Aligning these crosshairs with something that should be a white area will white-balance the entire image from that selection.

7 Tap the **Tick** to exit RAW Develop mode and enter the standard Snapseed editing homepage.

Most RAW files are supported by Snapseed. Some Android users may need to convert their native camera RAW files to DNG (Digital Negative) format, but this can be done easily using any of a number of free apps available online.

COLOR GRADING can be done at the RAW stage. RAW images allow more control and flexibility when you're making color adjustments. RAW files are always in color—in fact, what may appear solid white or solid black can still be manipulated to recover the color data. Even when you're planning a monochrome image, it is beneficial to shoot in RAW format and convert the image afterward rather than using a black and white filter.

CHAPTER 3
COMPOSITIONAL IMPROVEMENTS

The first stage in the photo-editing process is to improve the composition of the image using the Snapseed editing tools for **Cropping**, **Rotation**, and **Perspective**. There are two Snapseed photo-editing areas within the app:

TOOLS help you correct or perfect your image. They include features such as cropping and straightening and removing spots or scratches.

LOOKS used to be, and sometimes still is, called **Filters**. Here you can select from a number of pre-sets that will overlay your image, altering a range of features like the color or the contrast. I am not a fan of using these pre-set filters since they can often degrade the overall quality of images, especially for printing, as they are only really designed to be seen at screen resolution.

You can switch easily between these two areas by tapping **Tools** or **Looks** at the bottom of the screen to reveal a pop-up menu of tools.

TOOLS BEFORE LOOKS
We are going to be focusing our attention on the tools first. If you do feel the urge to apply a **Look**, I suggest you leave it until later in the edit.

You can tap and hold ⊞ within every **Tool** or **Look** to reveal the 'before' image. Or if you are on the Home screen, tap and hold the image itself.

ROTATE

I always begin any photo-edit with the **Rotate** tool. If your horizon line is not quite level, this tool will straighten it out automatically.

1 In the **Tools** menu, select Rotate.

Straighten Angle -2.40°

2 Snapseed will analyze the image and automatically rotate and straighten the horizon line. A message will flash up briefly at the top of the screen to tell you that the image has been auto-straightened. Swipe directly anywhere on the screen to free-rotate the image further, using the gridlines as a guide to adjust the **Straighten Angle**, which is shown in degrees in the bar at the top of the screen. When a photo is rotated, the image tilts and the edges are cropped. You can see what's being removed from the frame in the grayed-out areas beyond the edges of the image.

3 Select the **Tick** option to accept the changes and close the image, or you can tap on the **X** in the bottom left-hand corner of the screen to leave without accepting the changes that have been made.

You can flip the image completely by using the ▶┊◀ icon on the bottom menu.

Tap the ↻ icon at the bottom of the screen to rotate the image 90° clockwise in stages.

CROP

You can use the **Crop** tool to remove the edges of the frame if they contain any distracting elements to help improve the overall composition of the image.

1 In the **Tools** menu, select Crop.

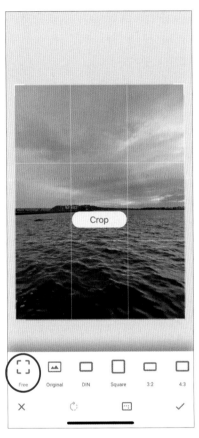

2 There are a variety of aspect ratios to choose from here, including the **Original** ratio, a **Square** ratio, and so on. Select **Free** to crop any edge individually without affecting the other dimensions.

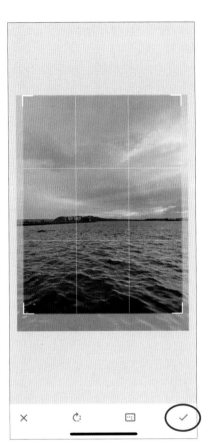

3 Select the **Tick** option to accept the changes and close the image, or you can tap on the **X** in the bottom left-hand corner of the screen to leave without applying the changes that have been made.

PERSPECTIVE

The **Perspective** tool is used to correct perspective issues such as leaning buildings. This is a common occurrence when taking photos of tall buildings from street level because, in order to include the whole building in the image, the camera is tilted so it is no longer parallel (and on the same plane) as the building. Every image is different, so the toolset you need within the various Perspective options will vary. So, have a play with the options and see what works best for the image you need to adjust.

1 In the **Tools** menu, select Perspective.

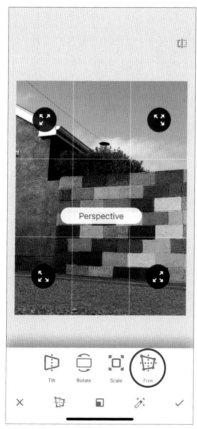

2 The tool opens with the **Free** option enabled, so you can make individual adjustments to any one of the corners independently of the others. These are indicated by black circles containing three white arrows. An on-screen grid is visible to help you arrange the horizontal and vertical lines perfectly.

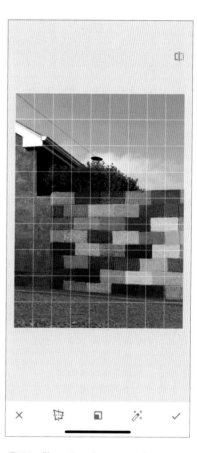

3 You'll notice that a much smaller, more precise grid appears when you drag your finger around the screen to start adjusting the perspective.

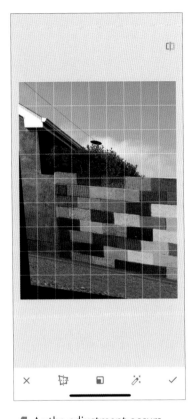

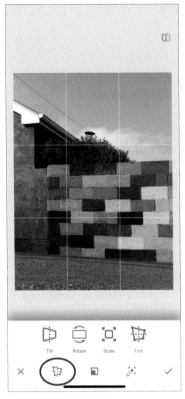

4 As the adjustment occurs, black areas will appear in the corners of the image where Snapseed is correcting the perspective. Snapseed will fill this empty space by sampling adjacent pixels and inserting them into the blank areas. This works well if the edges of the image are smooth and without much detail and texture. Clear blue sky is an easy fix for the app, for example. However, if the edges are textured, Snapseed may struggle to get a decent result. If the edges are not good enough, you have two options: you can either crop them out (see page 24) or clean (Heal) them manually (see page 32).

5 If the **Tilt/Rotate/Scale/Free** menu options disappear at any point, touch the **Perspective** icon (located second from the left at the bottom of the screen) to show them again.

6 Next, look at **Scale**. Use this option to adjust any areas of the image that look shrunken or oversized after the perspective adjustment has been made.

7 Use **Rotate** to straighten out any horizontal lines.

8 Select **Tilt** to correct the vertical perspective by dragging a finger up or down anywhere over the image until the lines are parallel, or to correct the horizontal perspective by dragging a finger left or right on the screen.

BEFORE

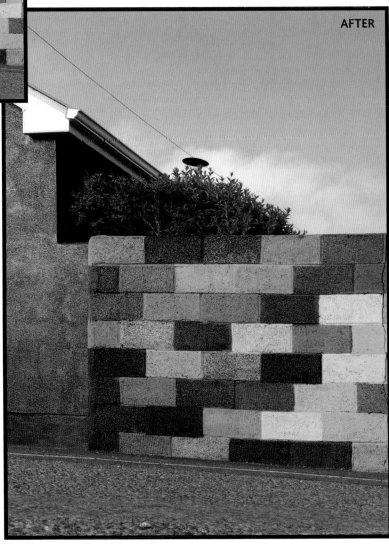

AFTER

EXPAND

The **Expand** tool is used to increase the image area of a photo by adding extra pixels to the outside edges of the frame. It can be used fairly successfully to give the appearance of enlarging the photo.

1 In the **Tools** menu, select Expand.

2 The tool opens with the image surrounded by a checkerboard mat into which the new pixels will be extended.

3 There are three fill options available for the expansion. The **White** and **Black** fill options will create a frame of the selected color.

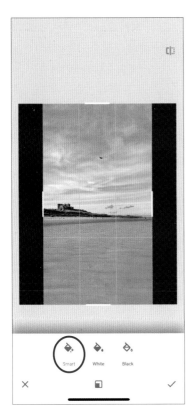

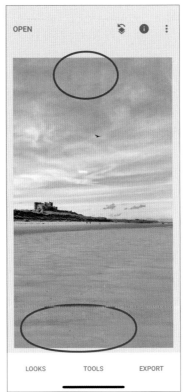

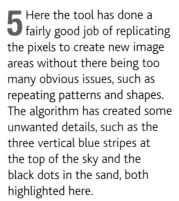

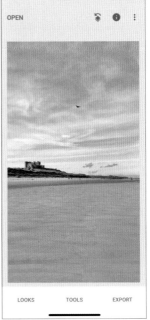

4 Select the **Smart** fill option to fill in the edges with a similar background to the photo. This works particularly well if there are fairly plain areas (like the expanse of sky and sand in this example) with flat colors and minimal texture and detail around the edge of the frame from which the feature can gather pixel information.

5 Here the tool has done a fairly good job of replicating the pixels to create new image areas without there being too many obvious issues, such as repeating patterns and shapes. The algorithm has created some unwanted details, such as the three vertical blue stripes at the top of the sky and the black dots in the sand, both highlighted here.

6 A small touch-up with the **Healing** tool may be required to remove any minor issues with the cloning process for the new pixels. Also look for any areas where there are repeating patterns and shapes that you don't want (see step 5) and remove them.

AFTER This photograph has now changed to a different image ratio which can be useful for stories in some social media platforms such as Instagram.

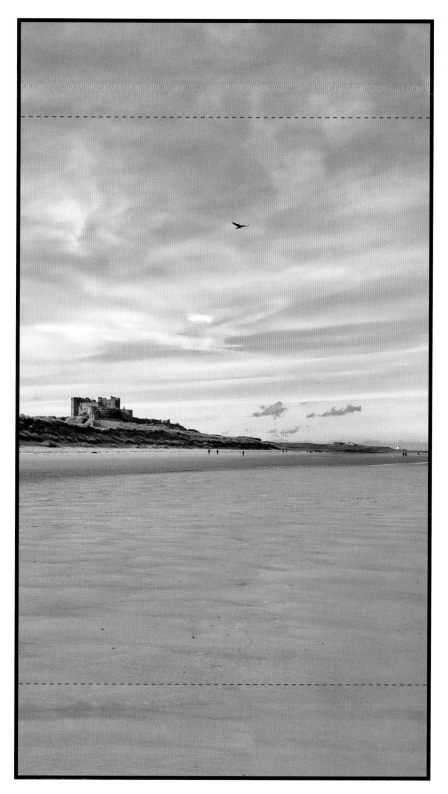

CLEAN UP

I also like to perfect my compositions by getting rid of the odd blemish from an image with the **Healing** tool, which removes small imperfections. This tool works best on areas that are fairly plain such as sea, sky, grass, skin, and so on. Removing distracting elements in this way can make or break a composition.

1 In the **Tools** menu, select Healing.

2 Zoom in to make it easier to see the areas that need healing. To do this, put two fingers on the screen, then make a pinch gesture outward (by dragging your fingers apart). Use the blue rectangle which appears inside the navigation frame on the bottom left of the screen to move around the image.

3 Swipe a finger lightly across the offending object. The area you have selected with the **Healing** tool will be replaced by pixels from the immediately surrounding area.

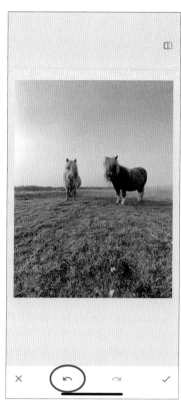

5 For very small objects, try just a light single tap on the object rather than a large swipe.

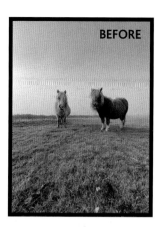

BEFORE

4 At the bottom of the screen, between the X and the Tick, are two arrows for **undo** and **redo** functions. If Snapseed doesn't clean the blemish up satisfactorily, press the **undo** arrow on the left side and swipe over the offending object again.

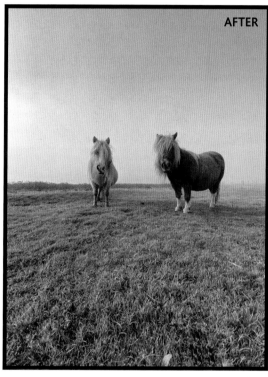

AFTER

There is a **BEFORE/AFTER** tool ◁▷ that enables you to compare the changes you're making. When you're in a Tool, press and hold the rectangle in the top right corner of the screen to see your before and after images. This may take a bit of practice to get right—just press and hold the rectangle to see the original image and release to see the changes you have made. If you're not in a Tool, you can press anywhere on the screen lightly to see the before and after images.

SAVING AND EXPORTING

At this stage it is a good idea to know how to save your file. There are a few options available in Snapseed: **Save**, **Save a Copy**, and **Export**.

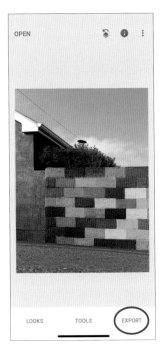

1 Starting with the Home screen, choose the **Export** option.

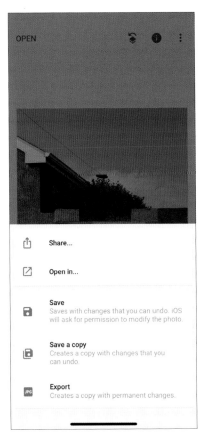

2 Your Save and Export options will appear here. The names of the options may vary from one device to another, but in theory the same options for saving are generally available. Try them out to discover exactly what they are called on your device.

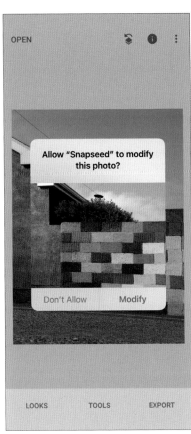

3 **Save** will overwrite the original image with the edited version. This is not ideal. If you try to do this, Snapseed will ask if you definitely want to modify this photo, as a safeguard measure.

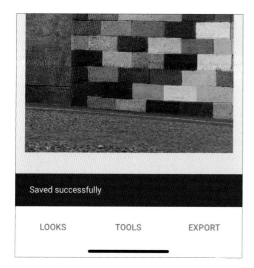

Saved successfully

LOOKS TOOLS EXPORT

Exported successfully

LOOKS TOOLS EXPORT

4 In general, it is best to **Save a Copy** as this preserves the original unedited image separately and creates a new version of the photo with the edits applied to it. Once the photo is saved, a **Saved successfully** ribbon will appear across the bottom of the screen.

5 **Export** will save a version of the image with all the edits permanently applied— these can no longer be changed after saving. Once the image is saved, an **Exported successfully** ribbon will appear across the bottom of the screen.

PRACTICAL ACTIVITY

It is time to have a play and see how you get on with this skillset. Open an unedited image in Snapseed on your phone or tablet and apply the following stages from the workflow:

1 ROTATE Start by making sure the horizon is straight. The vertical lines are addressed in Step 3.

2 CROP In this stage of compositional correction, you will be removing any extraneous information.

3 PERSPECTIVE Make any adjustments to the vertical lines, making sure to watch out for any issues created by Snapseed adding extra pixels to the image.

4 CLEAN UP With the three main compositional considerations out of the way, focus now on removing any distracting elements such as blemishes.

CHAPTER 4
GLOBAL ADJUSTMENTS

In this chapter and the next, we are going to explore the myriad methods for adjusting and enhancing images in Snapseed. If you're unsure about why you are making any of the edits in this chapter or what needs to be changed, you might want to refresh your understanding of the process of photography and the different factors involved such as exposure and lighting. Why not look at a comprehensive, jargon-free guide to the main concepts of photography, such as my first book *Smart Phone Smart Photography*, which will undoubtedly give you a deeper understanding of the reasons for the edits you make at this stage.

First, we are going to look at the global adjustment options available in Snapseed, such as exposure, color, and contrast corrections, and many more besides. Global adjustments are made to the entire image. They can be more general and less precise than local adjustments. To learn how to make precision adjustments to specific areas of an image, head over to Chapter 5 *Local Adjustments* to see what amazingly fine-tuned results can be achieved.

WHITE BALANCE

The **White Balance** tool applies different colors to the image in order to correct color casts and adjust the warmth or coolness of the image.

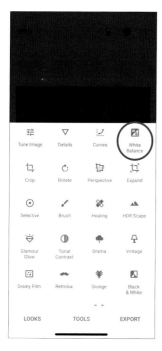

1 In the **Tools** menu, select White Balance.

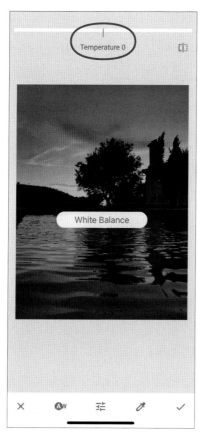

2 The tool will open with the **Temperature** setting activated and set to zero—the slider is visible at the top of the screen.

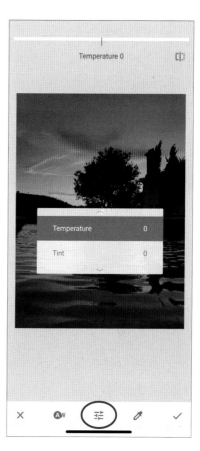

3 Access the White Balance options menu by selecting the **Sliders** icon at the bottom of the screen or by swiping up or down on the screen. A blue band will appear in the center of the screen, highlighting the selected option. Swipe left or right on the screen or the blue band to adjust the intensity of the selected option.

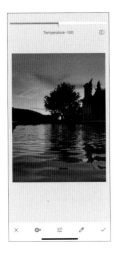

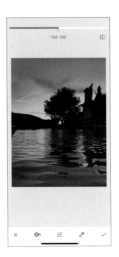

4 The **Temperature** option adjusts the colors to make them cooler (more blue). Here, we have swiped left to −100.

5 Here, we have swiped right to +100 to make the colors warmer (more orange).

6 The **Tint** option allows you to add a green tint—here, we have swiped left to −100.

7 Or you can add a magenta-pink tint to the image by sliding right (here, to +100).

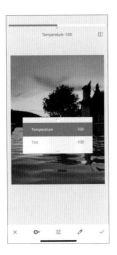

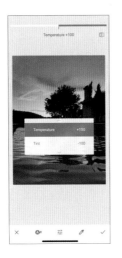

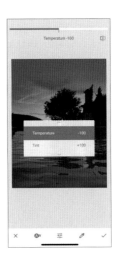

8 You can combine **Temperature** and **Tint** adjustments to create a further range of colors, such as this turquoise teal (Temperature −100; Tint −100).

9 You can also create yellow green (Temperature +100; Tint −100).

10 This example shows violet (Temperature −100; Tint +100).

11 This example shows red (Temperature +100; Tint +100).

12 If there is something white in the image, such as a white wall, an item of clothing like a white shirt, or even eye whites and teeth in a portrait, it is helpful to check Snapseed knows that this is what is to be seen as pure white, so it can make the other colors align correctly with this user-defined white point.

Use the **Eyedropper** tool located in the menu at the bottom of the screen to do this. Once selected, this tool can be used to identify what is meant to be white by placing the crosshair in the center of the magnifying glass over the area of the image that should be white. Snapseed's dropper tool will then automatically white-balance from this selected point.

13 This will change the Temperature and Tint on the slider at the top of the screen to anything in a range from −100 to +100 and give a clean white starting point.

14 Then, using the Temperature and Tint sliders, a few final tweaks can be made until the image looks just right.

TUNE IMAGE

Tune Image is used for global enhancements across the entire image to adjust and perfect a variety of aspects such as color, saturation, and contrast.

1 In the **Tools** menu, select Tune Image.

2 Swiping up and down on the screen anywhere within the photo area will reveal the **Tune Image** menu. Alternatively, use the **Sliders** icon at the bottom of the screen to access the menu that way.

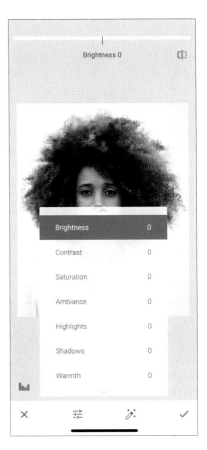

3 Select from the list of options in the center of the screen, tapping on the desired tool to highlight and activate it.

Now let's take a look at how each of these tools in the **Tune Image** menu affects the image. The slider across the top of the screen shows how much (or little) of the tool has been engaged or decreased.

 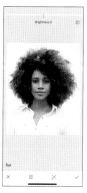 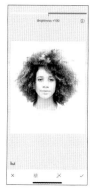 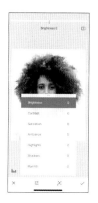

4 Brightness This will increase the brightness or darkness of the image by a factor of −100 to +100. Images can easily be overexposed (too bright) or underexposed (too dark) because of the way smart-phone cameras work or because of lighting issues at the time the image was shot. Use Brightness to correct or alter this to suit personal preference.

5 To make another adjustment, open the **Tune Image** menu again—by swiping up or down on the image or tapping on the Sliders icon at the bottom of the screen—to reveal the other options in the menu. Choose another option, then swipe left or right to adjust the setting. Repeat this process to use any other tools in the menu.

 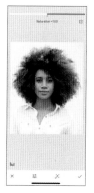

6 Contrast This tool will increase or decrease the difference between the light pixels and the dark pixels, giving brighter highlights and darker shadows. Contrast refers to the difference between tones in an image. It is primarily concerned with how sharply the colors stand out from one another and how much difference there is between the lightest and darkest tones as well as how the grayscale is defined.

7 Saturation This tool will increase or decrease the color intensity in a photograph. By setting the Saturation slider to −100 on the saturation scale in the Tune Image menu the photograph will be rendered monochrome/black and white. Saturation refers to the intensity of the color: the more saturated the image is, the more vivid its colors will appear. Lowering the saturation will effectively mute the image intensity, which can be useful when dealing with the tendency for smart-phone photography algorithms to slightly over-boost the saturation at the time of image capture.

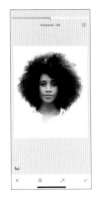 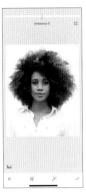 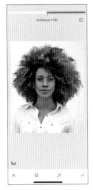

8 Ambiance The Ambiance tool is a tiny bit of Snapseed magic right there in the menu. Ambiance is a quick way to add an appealing pop of impact to an image. It simultaneously adjusts color saturation, brightness, and tonal contrast, giving most images some of that sought-after wow factor.

 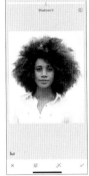 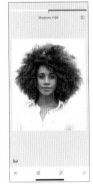

9 Highlights and **Shadows** The Highlights and Shadows tools can be used to make adjustments to either the shadows or highlights of the image, offering separate control of either the darkest or the brightest areas, without having to make global changes to the tonal range, which would affect the midtones too.

Highlights: Controls the darkness or lightness of only the image highlights.

Shadows: Controls the darkness or lightness of only the shadows (dark areas) in the image.

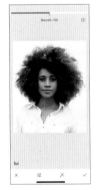 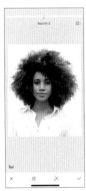

10 Warmth The Warmth tool sliders can be dragged left or right to add a cooler blue tone or a warmer orange tone to change the mood of the image.

THE HISTOGRAM There is an exposure guide available here in the form of a histogram. Use this when in the **Tune Image** tool to assess how the light information is distributed in the photo. It is initially displayed as an icon in the bottom left of the screen: **▟▟▟**. Tapping this icon will change it into a graph. Tapping it again will change the graph back into the icon. When the graph is activated, it visibly changes as adjustments are made to the image.

A histogram is a simple graph that appears in some of the tools, such as the **Tune Image** tool and the **Curves** tool, to help identify the correct exposure in the image. It shows the distribution of the tonal range from the black point on the left edge of the graph, through the gray midtones in the middle, to the white point on the right edge of the graph. Ideally, the distribution should reach from one end of the histogram graph to the other, and if it vaguely resembles a bell curve, it is probably correctly exposed, although this is not the case all the time.

PRACTICAL ACTIVITY

In this activity, you will practice using the **Tune Image** toolset by creating a high-key (more bright and highlight tones), black-and-white image.

If you're using an image that you have already worked on, then go to the **Edit History** dialog window (accessed at the top of the Home screen) and select **Revert** from the options, so you can remove all the edits and have a fresh image to start with. Now, to create a high-key, black-and-white image, work your way through the following simple steps as discussed in the preceding pages.

1 DESATURATE Start by desaturating the image using the Tune Image tool.

2 ADJUST TONAL RANGE AND EXPOSURE Dive deeper into the Tune Image sliders to adjust the tonal range and exposure accordingly.

3 CREATE AND SAVE Once you have created your image, you can save this as a Look (see pages 61–62).

CURVES ADJUSTMENT

The **Curves** tool can be used to adjust the hue, brightness, contrast, highlights, and shadows of photographs by dragging the blue dots (known as nodes) on a line down to decrease and up to increase. Working in this precise way gives you far greater control over the adjustments than is available when just using the contrast slider in the Tune Image tool.

Many people are afraid of using curves because they don't understand them, and it is fair to say that they can seem a bit intimidating to begin with. But fear not, they are actually very simple to understand and, once used a few times, there will be no looking back!

On opening the Curves tool initially, the first thing to note is that there is a straight line laid out diagonally in a square box from bottom left to top right rather than a curve as the name suggests. Although this may seem confusing, the tool is actually very simple to control and can be used to manipulate the color, shadow, and highlights in images with precision.

The diagonal line, often referred to as the contrast curve, represents the range of brightness and shadow in images. Below that is the histogram graph, which tells us how the light information is distributed in the photo. For more about the histogram, see *Raw Developing* (on page 20) and *The Histogram* (page 43).

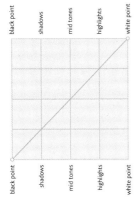

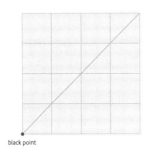

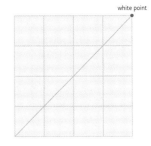

1 The curve begins with two node points on the diagonal line which will become the curve when they are dragged away from the line. They are located in the top right and bottom left of the grid.

2 The existing node on the bottom left of the diagonal line represents the darkest area of the image. This is known as the **black point.**

3 The existing node on the top right of the diagonal line represents the brightest area. This is known as the **white point**. Where the diagonal line crosses the center of the grid is where the midtones are found.

4 The bottom half of the diagonal line—indicated here with a pink arrow line—represents the **shadows**.

5 The middle section of the diagonal line represents the **midtones**.

6 The top half of the diagonal line represents the **highlights**.

7 In the **Tools** menu, select Curves.

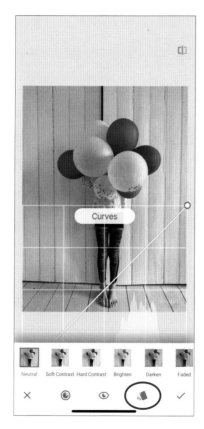

8 The icon in the bottom menu that looks like a little swatch book opens up a list of pre-set curves adjustments. By default, as shown in the thumbnails at the bottom, it pre-sets the curve to Neutral. After selecting some of the other options such as **Brighten**, **Darken**, etc., you can return to the **Neutral** pre-set at any time to reset the image to its original appearance.

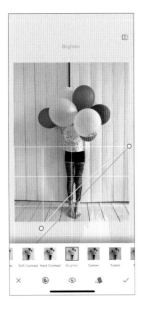

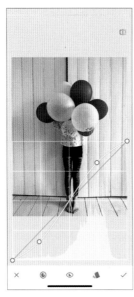

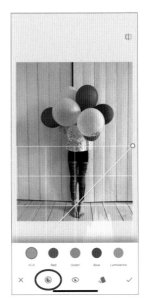

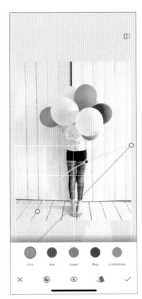

9 Play with the different pre-sets until you become familiar with how each of them affects the image. Here, for example, we see the **Brighten** pre-set being used. The gray line shows the neutral "curve" position, with the new curve as applied by the pre-set showing as a white line. No single pre-set suits every occasion, so spending some time getting to know them will make it easier for you to work out when to use them on a case-by-case basis.

10 Touching anywhere on the diagonal line will create an additional node point in the curve that you can drag up or down. Dragging a node point on the curve will affect the part of the histogram seen directly below the node.

11 As well as the pre-sets it is also possible to adjust the curves manually by tapping the circular icon in the bottom left of the screen. This will reveal the different curve adjustment options: **RGB**, **Red**, **Green**, **Blue**, and **Luminance**.

12 The **RGB** curve is selected automatically to begin with and raising or lowering this curve brightens or darkens all the colors in the image at the same time. You can increase the lightness or darkness of each of these colors individually by using the **Red**, **Green**, and **Blue** icon options (as explained in the following steps).

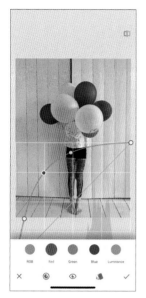

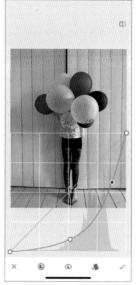

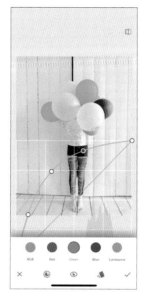

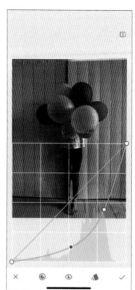

13 **Red curve** Raising the red curve above the diagonal median line running from bottom left to top right will increase the red hues in the image.

14 Dragging the red curve down below the diagonal median line running from bottom left to top right will increase the cyan (blue/green) hues in the image.

15 **Green curve** Raising the green curve above the diagonal median line running from bottom left to top right will increase the green hues in the image.

16 Dragging the green curve down below the diagonal median line running from bottom left to top right will increase the magenta (purple/pink) hues in the image.

USING NODES The curve is also known as an S-curve because when used correctly the shape of the curve looks like the letter "S" (**A**).

Dragging the nodes to any extremes, such as straight lines, right angles, shelving, or step patterns, and touching the ceiling or floor of the Curves box has a detrimental effect on some areas of the image and is to be avoided. Whenever the line skims across the ceiling (Highlights) or floor (Shadows), it is being forced to total black or total white, which is far from ideal (**B**).

Remember, a curve should be soft and rounded to work best!

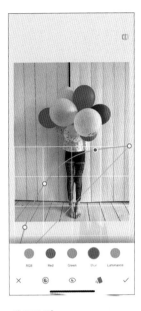

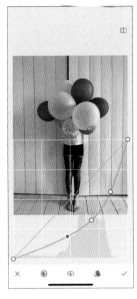

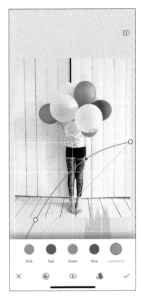

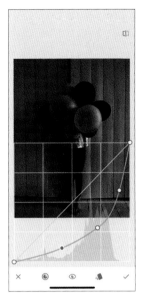

17 **Blue curve**
Raising the blue curve above the diagonal median line running from bottom left to top right will increase the blue hues in the image.

18 Dragging the blue curve down below the diagonal median line running from bottom left to top right will increase the yellow hues in the image.

19 **Luminance**
This affects the brightness of all the colors at the same time, whereas RGB affects the black and white points individually for each of the colors. Raising the Luminance curve increases the lightness of the hues.

20 Dragging the Luminance curve down increases the darkness of the hues.

Tapping the **Eye** icon in the bottom menu will hide the curve line and bottom menu ribbon, allowing you to see the effects on the image in a less cluttered workspace.

To see the Curves tool in action, check out **Case Study 1** *Light and Shade* (page 92) and **Case Study 2** *Fairy Lights Edit* (page 96).

TONAL CONTRAST

The **Tonal Contrast** tool creates contrast in the different areas of the tonal range, which is simply the range of tones between the darkest and brightest areas of an image. The darkest area represents pure black and the brightest is pure white. The Tonal Contrast tool allows for an independent selection of the Low, Mid, and High Tones in order to increase the level of definition in these areas and sharpen the detail contained within them.

1 In the **Tools** menu, select Tonal Contrast.

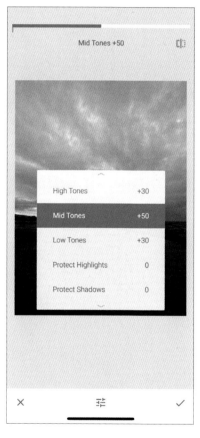

2 Slide up or down anywhere on the image to access the menu or open this by tapping the Sliders icon. When selected the tool automatically applies an adjustment across all three tonal ranges. It inserts +30 in the **High Tones**, +50 in the **Mid Tones**, and +30 in the **Low Tones**. It may be necessary to reset some of these adjustments to zero if they appear too strong or harsh.

You can engage the **Protect Highlights** and **Protect Shadows** options if necessary to protect the extreme ends of the tonal range from being adversely affected by the adjustments you've just made. This gives a further degree of control when adding definition to select areas of an image.

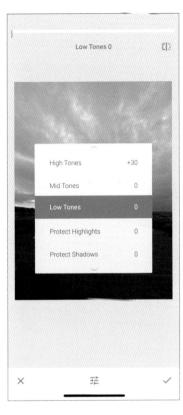

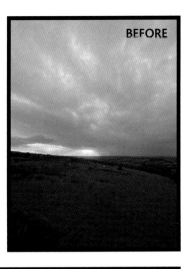

BEFORE

4 Tap and hold the ⌐⌐ icon to reveal the before image and make sure it is still nice and subtle before tapping the Tick on the bottom right of the screen to accept the changes.

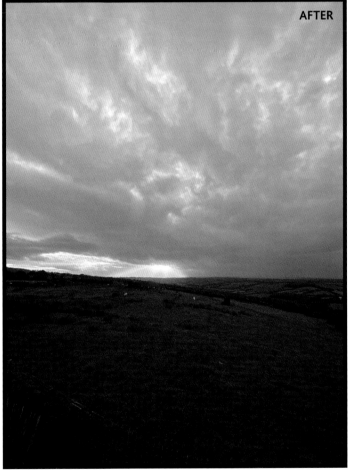

AFTER

3 I often use this tool to increase drama in the sky. As it is only used to intensify the cloud detail, you only need to apply the **High Tones** adjustments. The **Mid Tones** and **Low Tones** surges can be automatic—these can both be set back to zero.

In keeping with the "keep it subtle" motto that all good photo-editors should adhere to, it is a helpful rule of thumb to keep the High Tones adjustment to about +30. If this effect is over-used, the image can look overdone and fake, as if it has had a heavy-handed HDR (High Dynamic Range) effect applied to it, which is not ideal.

LAYERS

Every time a different tool is used Snapseed creates a fresh layer for the edit. Think of this as a bit like applying several layers of paint to a bare wall. However, unlike in painting where previous layers cannot be re-done, with Snapseed's versatile and clever Layers stack feature it is possible go back and revisit each of these layers as desired. This non-destructive editing allows for carefree experimentation with tools without the fear

of being unable to undo the editing later. Simply delete or modify any of the individual edits that have been applied at any point in the editing process without having to re-do everything that came afterward.

Now that we have seen how a few edits can be applied to an image, let's explore the **Layers** stack and see how this can be used in a workflow for fine-tuning edits and masking out edited areas.

1 To access the **Layers** stack, the **Edit History** dialog window needs to be opened. To open this, tap the **Edit History** icon at the top of the Home screen—this looks like a pair of square layers with a curved arrow on top.

2 In the menu that appears are the various options regarding the history of the photo-edit. It is possible to undo the last edit performed. Selecting **Undo** multiple times will continue to undo the edits in the order they were done. There is the option to **Redo** the last step here, too. If an edit has been undone that subsequently needs to be reinstated, this is how you do that. To start again completely, there is the option to **Revert** to the original image.

3 In terms of layers, however, it is the **View edits** option that is key. When selected it opens up the entire edit history. Now the **Layers** stack containing all the edits carried out on the image will be visible, with the most recent at the top of the stack highlighted in blue (in this case, the White Balance option).

4 Selecting any of the edit layers in the stack and tapping the small arrow on the left will reveal a new fly-out menu of three options. Use the **Dustbin** icon to completely delete this layer of the edit.

Tapping on the **Sliders** icon will open the **Tools** window again so the edit can be modified further. Once this new edit adjustment has been saved, it will return to reopen the stacks menu.

The **Brush** icon in the center reveals some masking options. Masking is a very useful tool for applying the effect of the edit in this layer to just one portion of the image. The area is selected by brushing over it. You can learn more about masking on page 57.

5 When tapping an edit in the stack, the edits above it are temporarily removed from the image. These edits can be brought back by tapping them in the stack, so be sure to tap the uppermost filter to re-enable all the edits in the stack before exiting the window. When you have finished modifying the edits, tap the back arrow in the top left of the screen to exit the **Edit History** window.

PUTTING TOOLS AND FILTERS IN ORDER

It is important to put the tools and filters in the correct order within the edit stages, so if one gets missed out, it can be inserted into the stack later on. To insert a tool or filter effect into the stack, use the following steps:

1 Open the Layers stack window as described in Step 1 (page 51).

2 Now select and highlight the tool or filter that should be applied directly before the new edit or effect. With this layer highlighted, and all the layers above it grayed out and temporarily disabled, exit the stacks area. Then undertake the desired edit as normal.

3 Now return to the stacks window and highlight the uppermost edit in the stack to reinstate all the other edits, with the new edit inserted earlier into the stack.

4 It is possible to copy and paste the edits to move them around within the stack. This menu is accessible by tapping the **Three Dots** icon in the top right of the screen (**A**). There you are given three options: **Copy**, **Replace**, and **Insert**.

5 To move the edit elsewhere in the stack, first make a copy of it. To do this, use the **Copy** option in the Three Dots menu (**B**). To insert the edit in the new location in the stack, simply highlight the edit in the layer stack directly below the desired insertion location.

6 Now re-open the Three Dots menu and select **Insert** to place the edit in the location selected in the stack (**C**).

COPYING AN EDIT STACK

It is also useful to copy a set of edits from one image to another. In fact, it is possible to copy an entire edit stack to use for another image. Here's how:

1 Open the Layers stack view, select the **Three Dots** menu at the top of the screen, and then select **Copy**.

2 Exit the Layers stack and open the next image.

3 Now return to the **Edit History** dialog window and select **View edits** once more.

4 Once you are in the Layers stack area, select the Three Dots menu again before choosing from the options to **Replace** or **Insert**.

5 If **Replace** is selected, the stack will be applied exactly as copied, overwriting any existing editing previously done using **Tools** and **Looks**. If **Insert** is selected, the stack will be added to the new image along with any existing tools or looks.

A stack remains copied until it is overwritten by another stack, so there is no rush to replace or insert it into another image as it will still be in the clipboard until another stack is copied. Once inserted, in order to see the effect, all the layers above it in the stack must be reinstated. This is done by selecting the uppermost layer.

Just to be on the safe side in case edits get muddled, the **Revert** option in the first introductory Layers option window will turn the image back to the unedited version and, if necessary, selecting **Undo** again will undo this **Revert** in turn!

LAYER ASSESSMENT (AKA INTERROGATING THE STACK)

The Layers feature is a useful tool for finding errors in the editing process by interrogating the Layers stack in real time. This highlights areas that might be being "overcooked" in the edit and ensures that the overall edit is kept clean and isn't too over-done.

1 Begin by highlighting the layers one at a time, starting from the bottom and working your way up to the top of the **Layers** stack. As each new layer is reactivated, the layers that are cause for concern and may need further attention become apparent. Edit the layers again or mask out some of the edit (to learn more about masking, see page 57).

2 To revisit the edit, simply open the layer's fly-out menu by tapping the little left-facing arrow that appears in the bottom left of the layer when the layer is highlighted in blue. Now select the **Sliders** icon (on the right in the blue menu) to re-enter the edit on this layer.

3 Make any adjustments necessary to the edit (here the **Brightness** is being adjusted), then tap the **Tick** to accept the changes to the edit (or **X** to reject the changes).

4 Snapseed will now return to the Layers menu. Continue to interrogate the stack and make corrections and adjustments all the way up to the top of the stack. The top layer will now be highlighted in blue to indicate that it has been selected.

Exit the Layers stack area by tapping the arrow in the top left of the screen.

MASKING

Certain areas of the edit can be hidden or revealed with the **Masking** brush in the Layers stack. Being able to turn a global adjustment into a selective local adjustment is a significant expansion of the editing capability for each tool and filter in the Snapseed arsenal, providing the opportunity to undertake an advanced editing workflow on a mobile device.

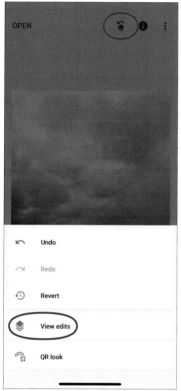

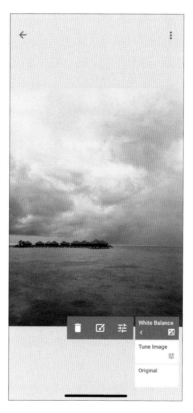

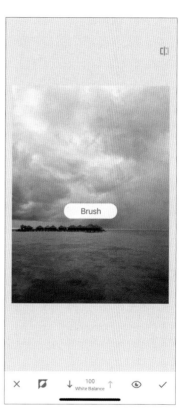

1 To illustrate the masking technique, here is an image that has had the **White Balance** boosted to increase the intensity of the turquoise-blue color of the ocean. However, this edit has made the sky too blue. To correct this, go to the **Edit History** dialog window in the Home screen, then choose **View edits** to access the Layers stack options.

2 Highlight in blue the edit layer to be masked (in this case, the **White Balance**). Now simply open the layer's fly-out menu by tapping the little left-facing arrow that appears in the bottom left of the layer when it is highlighted blue. Select the **Brush** tool in the middle of the menu.

3 On opening the **Brush** tool, the layer edit's effect has been masked.

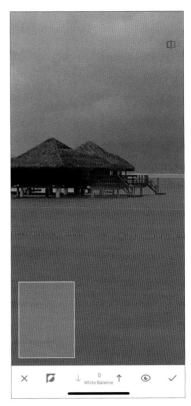

4 Begin painting over the image using a finger or stylus pen to unmask the area and add the effect back in. Use the up and down arrows in the menu bar at the bottom of the screen to change the density/opacity of the mask by factors of 25 at a time.

5 Tap on the **Eye** icon at the bottom of the screen to see the effect on the image. This will show all the areas that are being affected (in this case, the White Balance effect) as a red overlay. This allows you to see what is being included and excluded by the mask.

6 If too much of the area has been selected, set the opacity to zero, which effectively turns it into an eraser, and then paint out the areas to tidy up the selection. Use the range of densities from 25 to 100 to add the mask in a gradient to help blend the edges and prevent anything too hard appearing in the final mask.

7 Select the **Invert Mask** icon to flip/reverse the overlay between showing what is masked and showing what is not masked. This is useful when you are painting a mask on a very small area because it allows you to paint in just that small part instead of painting out everything else in the image, which would be time-consuming.

8 Pinch to zoom in and use the blue rectangle in the navigator rectangle to move around the image and see what needs to be tidied up. Pinching to zoom in makes the **Brush** tool size larger and zooming out makes it smaller again.

9 Tap the **Tick** to accept the changes and return back to the Layers menu. Ensure you are on the top layer before leaving.

LOOKS/STYLES

Snapseed offers a range of pre-sets and these are made from combinations of various edit stages. You can use these to alter the style of your photos quickly and easily. Create personalized looks by saving your edit stages for an image to use on other images afterward. For more guidance on how to create your own **Looks**, see pages 61–62.

The range of **Looks** pre-sets are located in the menu bar at the bottom of the screen, labeled "Looks" (on Apple iOS devices) or "Styles" (on Android devices). For consistency they are called Looks in this book.

Navigate through the various options to get a feel for what each one looks like and see which appeals to you the most. You'll find that some suit your style of photography better than others. If you like the result, tap the **Tick** to accept the edit.

CREATE YOUR OWN LOOKS

When editing multiple images from the same shoot it is useful to be able to rapidly apply the same set of edits to each of them. This enables you to do a quick edit for the full set of images, perhaps so you can select the best one as soon as the edits are in place. This is where creating personalized edits or "looks" comes in useful. It is possible to save a series of edits and rapidly apply them by doing the following:

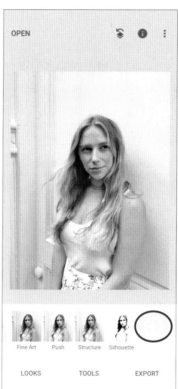

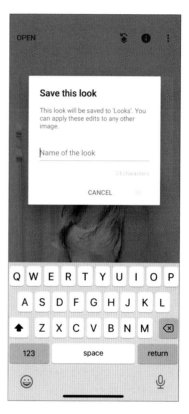

1 To create a Look from an edit on a photo, select the **Looks** option at the bottom of the Home screen. (If the word "Looks" doesn't appear, there may be a rainbow shape instead.)

2 Swipe through all the Looks available until at the very end of the row, on the far right, you will find the **Add Look** (+) icon.

3 Selecting the **Add Look** (+) icon opens up a dialog box where you can manage the look.

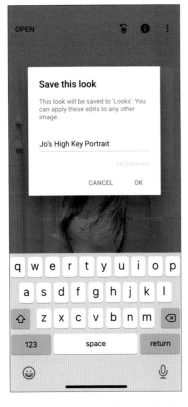

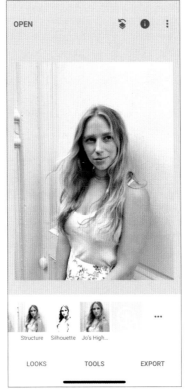

4 Give a name to the new Look. Make this something personal to you, so it can be easily identified from the default looks that already exist within the Snapseed app. You have a maximum of 24 characters.

5 The new custom Look (here, Jo's High Key Portrait) appears in the **Looks** list at the bottom of the screen. This Look can be applied to any photo that needs similar editing in the future.

Your personalized Looks can be managed by clicking on the **Three Small Dots** icon in the bottom right of the list after the **Add Look** (+) icon.

6 You can use the **Three Small Dots** icon to look at all the Looks you have created and rename them using the **Pencil** icon or delete any that are no longer needed with the **Dustbin** icon.

VIGNETTE

The **Vignette** tool can add atmosphere to an image by subtly darkening its outer edges and creating a spotlight effect in the center. This is done by changing the darkness or brightness of the inner or outer parts of an image. It is generally used to darken the outer edges slightly to draw attention to a certain area using light and shade.

Be wary of "over-cooking" the Vignette effect because it can rapidly make a good photo look bad. Subtle use of a vignette will give the effect of light and shade in a pleasing way that draws the viewer's eye into the photo and to the spotlighted subject.

1 In the **Tools** section, select **Vignette**.

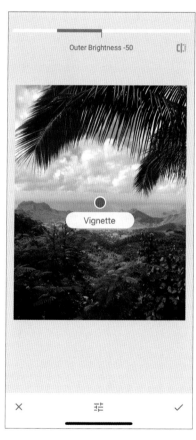

2 Now move the blue spot around until it is sitting over the area that is going to be the spotlight.

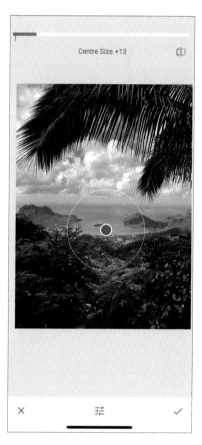

3 Pinching in or out with two fingers will increase or decrease the **Center Size** and the area that will be affected by the vignette.

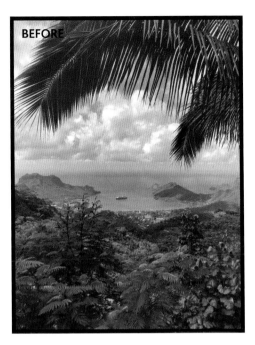

BEFORE

4 The default setting for the Outer Brightness is −50. Swiping left or right will darken or lighten the outer area, and the slider at the top will show the amount of adjustment that is occurring as a plus or minus value. Set the Outer Brightness to −100 briefly, just to see where the area affected by the edit will be.

5 Now use the **Sliders** icon at the bottom of the screen or swipe up or down to open the **Vignette** menu, which offers the options for controlling the Outer Brightness and Inner Brightness. In this example, the Inner Brightness is set to +5 and the Outer Brightness is set to −20, to slightly darken the edges of the image. This gives a pleasing color gradient to the colors in the sky and draws the eye to the central area.

6 Use the **Before/After** function to make sure the effect has not been overdone. This combination of settings draws the viewer's eye to the more important, brighter part of the scene and adds some atmosphere, but is still subtle enough to be barely visible as an effect.

I have developed a far more advanced and sophisticated method for creating a vignette that protects the Highlights and produces the light and dark areas in any bespoke shape, as opposed to the uniform circle created by the Vignette tool. This method is explored in **Case Study 1** *Light and Shade* (see page 92).

PRACTICAL ACTIVITY

Here, we are going to use all the stages in the list below in the order they were explored in this chapter. The aim is to solidify your learning and skillset. Take your time—even if it takes 30 minutes or an hour, don't rush. And remember to visit the Layers stack and assess the edits frequently, not only to check your progress, but also to see if you need to modify, mask, or even delete any of your edits so far.

Open a fresh unedited image. If you have opened a previously edited version of a photograph, then go to the **Edit History** dialog window (accessed at the top of the Home screen) and select **Revert** from the options to delete all previous edits. This will remove all the edits and give you a fresh image to start with.

To begin with, make an assessment of the image (see page 19) and then use as many of the following list of tools as possible, as and when they are deemed applicable. I have numbered the list to reinforce the workflow order in a linear fashion. Don't forget to make use of the layers in the following ways too:

• Interrogate the Layers stack a few times to assess your progress.

• Move, Copy, and Insert edits into the Layers stack, to experience doing this.

• Try to use some layer masking, so the global adjustment becomes a local adjustment, just to practice this skillset.

1 ROTATE Use the **Rotate** tool to fix wonky horizons and other lines.

2 CROP Use the **Crop** tool to improve composition and remove distractions.

3 PERSPECTIVE Use the **Perspective** tool to repair any leaning buildings and other converging verticals.

4 CLEAN UP Use the **Healing** tool to clean up any blemishes and distractions.

5 WHITE BALANCE Use the **White Balance** tool to correct any color casts and perhaps add a fresh color scheme.

6 TUNE IMAGE Use the **Tune Image** tool to make a range of enhancements to the image.

7 CURVES ADJUSTMENT Use the **Curves** tool to adjust the hue, brightness, contrast, and highlights and shadows.

8 TONAL CONTRAST Use the **Tonal Contrast** tool to enhance the local contrast in each of the tonal ranges.

9 LAYERS Use the **Layers** stack to assess the edits (as explained in Layers Assessment, page 51).

10 LOOKS AND FILTERS Access the **Looks** menu and filters to alter the style of the image.

11 VIGNETTE Use the **Vignette** tool to add light and shade for impact and atmosphere.

12 SAVE Save all your edits to create a **Look** that you can return to for other images.

13 EXPORT Export to save a permanent version of the final image with all the edits applied.

CHAPTER 5
LOCAL ADJUSTMENTS

In this chapter, we will explore the creative potential of the local photo-editing tools. This suite of selective editing tools adjusts different areas of an image separately, elevating the editing capabilities of this app to an advanced degree of flexibility and subllety.

This chapter demonstrates how to isolate specific image areas and explains which tools work best for each scenario.

SELECTIVE ADJUSTMENTS

The **Selective** adjustments tool creates incredibly precise selections in a very simple manner. You can use this tool to make surprisingly intricate enhancements to very small areas of the image in just a matter of seconds in a highly intuitive way.

The **Selective** adjustments tool uses zones to alter different areas, which is particularly useful for making adjustments to light and shade separately and with precision. The tool uses control points to specify these zones. With this method it's possible to tap on an area in a photo to select a zone for localized adjustment based on parameters such as the pixel color or tonal range (light and shadow), among others.

1 In the **Tools** menu, choose Selective.

2 The **Selective** adjustments tool opens without any control points in place.

3 Use the (+) icon at the bottom of the screen to place a control point (a blue circle with a white "B" inside). Drag the point to the first area of the image that requires an adjustment.

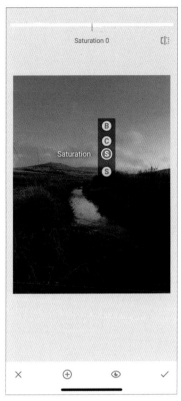

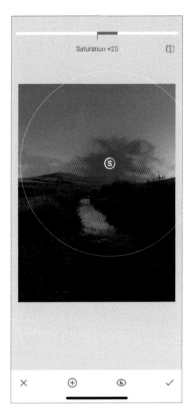

4 For greater precision, press and hold the blue control point to turn it into a magnifying glass. You can position the tool more accurately by placing the crosshairs in the magnifier in the exact position needed as the center of the adjustment zone.

5 Slide a finger up and down anywhere on the screen to reveal the edit function menu for the control points. Then select to adjust the **Brightness**, **Contrast**, **Saturation**, or **Structure** for the selection. Here, **Saturation** has been selected.

6 Use a pinching gesture to see and alter the area that will be affected—this will be indicated by a red overlay. To increase or decrease the size of the affected area, use a pinching-out or pinching-in gesture to change the number of pixels selected, as indicated by the change in size of the red overlay.

Tap and hold the **Eye** icon at the bottom of the screen to hide all the control points briefly, so the Selective adjustment effects are visible in their entirety, without the point distracting the eye.

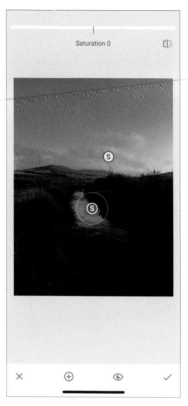

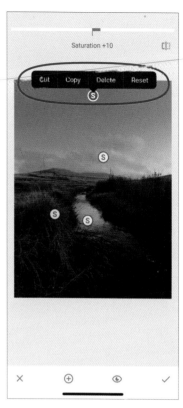

7 When adding Saturation to an image, look for places where color exists and boost it slightly. But don't be heavy-handed. Here the pinky orange color in the cloud will be boosted slightly by dragging a finger left or right on the screen to change the Saturation. Remember to keep the effect subtle.

8 Tap the (+) icon at the bottom of the screen to add another control point (you can have a maximum of eight). Here, another control point has been added to the stream. Pinch again to alter the number of pixels affected, then slide left or right to add the effect.

9 To edit a control point, first ensure that the point is highlighted in blue. If it is gray, simply tap on the point to activate it. The following options will then appear: **Cut**, **Copy**, **Delete**, and **Reset**.

When adding spots of light and shade, try to work with the light and shadow already in the picture. Enhance what is there, if possible, as this will keep the image looking most natural.

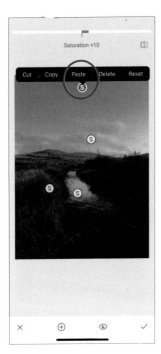

11 To control the area of the effect more precisely, add another control point to the area that is to be excluded. In this example, two **Saturation** points have been added, one to the left and one to the right of the stream section. These points have been pinched out to select just the grass but set to zero to prevent the Saturation control point in the river (set to +31) overspilling and creating a saturation effect in the grassy area.

10 Once a control point has been copied, it can be pasted elsewhere in the image to create the identical effect there. Add a new control point, then press and hold, and select **Paste** from the pop-up menu to duplicate the effect from the copied control point to this one.

The **Selective** adjustments tool is great for portrait smoothing. Use it to reduce visible pores and texture in the skin to make it look smoother. To do this, add a point on the skin, slide to access the menu options, and select **Structure**. Pinch out, selecting the entire skin area, then reduce the detail in the structure by sliding the tool strength to the left to smooth the skin.

PRACTICAL ACTIVITY

In this activity, you are going to practice using the **Selective** adjustments tool to add various points of light, shade, contrast, and structural sharpness and to increase the color saturation selectively.

If you are using an image that you've already worked on, then go to the **Edit History** dialog window (accessed at the top of the main Home screen) and select **Revert**, so you can remove all the edits and have a fresh image to start with.

1 ADD CONTROL POINT Using the Selective adjustment tool, add a control point to your image.

2 ADJUST AFFECTED AREA Vary the size of the affected area using a pinching gesture.

3 ADD MORE CONTROL POINTS Add further control points to your image and use some of these to define and limit the selections of the other control points.

4 COPY Make a copy of a specific control point and paste it elsewhere in the image.

5 DELETE Remove a specific control point.

6 SAVE Tap on the **Tick** to accept the changes made to the image.

BRUSH TOOL

The **Brush** tool is great for correcting and adjusting local colors and lighting. The brush effect is cumulative, so if you touch the area more than once, it will apply the effect each time.

Because the brush is currently being used as the Brush tool, you cannot also use it to mask in and out, as it cannot be used for two separate purposes at once. If you open up the Mask layer, you'll see there is no Brush tool option. To change the size of the brush, zoom in or out and the circular brush size indicator will change size accordingly.

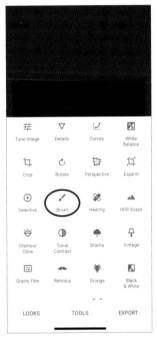

1 In the **Tools** menu, select Brush.

2 You will see a range of specific brush tools at the bottom of the screen. If these tools disappear at any time (and they do sometimes), just tap the **Brush** icon at the bottom to make them reappear.

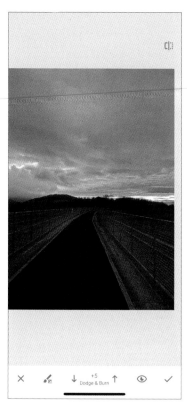

3 Dodge & Burn Dodging and burning is used to add points of light and shadow to an image. Use your finger to brush the areas you want to dodge and burn, swiping on the screen.

The Dodge & Burn brush brightens or darkens the areas painted on the image. Use the up or down arrows at the bottom of the screen to adjust the value. It brightens with a brush stroke by a factor of +5 or +10. It darkens with a brush stroke by a factor of −5 or −10.

Halfway between the + and − settings is the **eraser** tool. Select this and brush over any area where you would like to remove brush strokes. Here the Dodge & Burn brush has been used at +5 to make the railings in this image brighter.

The **Eye** icon is a useful way to check what effect the brush is having, so turn it on and off to see the red overlay indicator as usual. In this image, the railings have been highlighted as is indicated by the red overlay.

4 Exposure The Exposure brush increases or decreases the exposure painted on the image. Use the up or down arrows at the bottom of the screen to adjust the value. It increases the exposure with a brush stroke by a factor of +0.3, +0.7, or +1.0. It decreases the exposure with a brush stroke by a factor of −0.3, −.07, or −1.0

Halfway between the + and − settings is the **eraser** tool. Select this and brush over any area where you would like to remove brush strokes. Here, a brush stroke of Exposure with a large brush size was brushed over the pathway to lighten it slightly at a strength of +0.3.

5 **Temperature** Use the Temperature brush to apply warm (more orange) or cool (more blue) tones with brush strokes. Use the up or down arrows at the bottom of the screen to adjust the value. It adds warmth with a brush stroke by a factor of +5 or +10. It adds coolness with a brush stroke by a factor of −5 or −10.

Between the + and − settings is the **eraser** tool. Brush over any area where you would like to remove brush strokes. In this example, the Temperature brush was used at a strength of +5 to increase the orange and yellow sunset hues on the horizon line.

6 **Saturation** The Saturation brush increases or decreases the vibrancy of the colors with a brush stroke. Use the up or down arrows at the bottom of the screen to adjust the value. It increases the vibrancy with a brush stroke by a factor of +5 or +10. It decreases the vibrancy with a brush stroke by a factor of −5 or −10.

Between the + and − settings is the **eraser** tool. Brush over any area where you would like to remove brush strokes. Here, the Saturation brush was used over the whole sky at a strength of +10 to increase the vibrancy of the colors.

DETAILS TOOL
FOR STRUCTURE AND SHARPENING

This refers to creative sharpening as opposed to input or output sharpening. Selective sharpening is used here to enhance specific areas of the image if they look a little soft. Bear in mind, however, that detail cannot be restored if it was not there

to begin with. Sharpening is simply the act of increasing the local contrast of details within the image. It is most important if print output is intended as the final destination of the photograph.

1 In the **Tools** menu, select **Details**.

2 Like the other Snapseed tools, swipe on the screen or tap the **Sliders** icon at the bottom to reveal the options menu. Then, swipe horizontally across the screen or on the settings bar at the top to adjust the individual settings.

3 **Structure** is used to increase the amount of detail in an image using a unique algorithm to bring out the texture of objects throughout the photo without affecting the edges of the objects. Here, the texture of the ferns in the foreground is clear and detailed.

4 The **Structure** tool tends to produce the best results, as the **Sharpening** tool can reduce the quality of the image by introducing unnecessary grain and should therefore only be used in moderation. Zoom in to see what effect the tool is having on the image at a greater magnification and check that it is not creating unwanted noise or grain.

5 **Sharpening** looks for differences/contrast in areas next to each other in the image and enhances that contrast. Be wary, though, as this can mean borders are emphasized. This leads to halos, which are always to be avoided!

6 Use your fingers to pinch and zoom in and out to keep a constant check on the quality of the detail being added. Try to keep this to the absolute minimum to avoid the introduction of any quality issues.

7 Tap the **Tick** at the bottom right of the screen to save the changes and exit.

PRACTICAL ACTIVITY

For this activity, we are going to use all the tools explored in the previous chapters to cement the workflow.

Open a fresh unedited image. If you're using an image that you have already worked on, then go to the **Edit History** dialog window (accessed at the top of the main Home screen) and select **Revert** from the options to delete all previous edits. This will remove all edits and give you a fresh image to start with.

1 ASSESS THE IMAGE Make an assessment of the image first.

2 ROTATE/CROP/PERSPECTIVE Use these three tools to improve the compositional elements of your photograph.

3 CLEAN UP Use the Healing tool to clean up any blemishes and distractions.

4 WHITE BALANCE Use the White Balance tool to correct any color casts or change the colors in your image all together.

5 TUNE IMAGE Use the Tune Image tool to make a range of adjustments to contrast, lightness and tonal range amongst others.

6 CURVES Use the Curves tool to adjust the hue, brightness, contrast, and highlights and shadows.

7 TONAL CONTRASTS Use the Tonal Contrast tool to enhance the local contrast in each of the tonal ranges.

8 LAYERS Use the Layers stack to assess the edits (as explained above).

9 LOOKS AND FILTERS Access the Looks menu and Filters to alter the style of the image.

10 MASKING Use the Masking brush to make a global adjustment into a local one, and enhance only part of your image.

11 VIGNETTE Use the Vignette tool to add light and shade impact.

12 SELECTIVE ADJUSTMENTS Use the Selective tool to make adjustments selectively, based on similar pixels or colors..

13 BRUSH Use the Brush tools to brush on adjustments to light, saturation, and temperature.

14 DETAILS Use the Details tool to improve structure and sharpening.

15 EXPORT Export the final image to save the edits you have applied permanently.

CHAPTER 6
BEYOND THE BASICS

For a bit of next-level finessing of your images, it is time to go beyond the basics and explore **Filters**, using the **Lens Blur** tool for depth of field, and the **Portrait** tool for portrait enhancement.

FILTERS

As well as the editing tools Snapseed also offers various filters that you can play with and apply to images. This section gives a brief overview of the Filters found in the **Tools** menu; there are many more in the **Looks** menu.

HDR SCAPE

In high dynamic range (HDR) mode, the camera takes three or more photographs, one exposed for highlights, one for mid-tones, and one for shadows, then merges them to create one image that has a strong presence across the tonal range. HDR Scape uses tone mapping to apply a larger-than-life HDR effect to images. This enhances the difference between the extreme ends of luminosity in a photo by opening up the shadows and enhancing highlight detail. The effect must be used with a light touch, however, because it can create too much detail and texture, and rapidly look overdone and fake.

There are four different options within this Filter—**Nature**, **People**, **Fine**, and **Strong**—and the Filter Strength, Saturation, and Brightness of each can be adjusted.

In photography, HDR works by taking multiple images with different exposures, some darker and some lighter, and then merging them in the zones. It is a useful filter for landscape photos where there is good contrast between the lights and shadows. However, it is less successful for portraits, as it ages the skin and makes pores and wrinkles more defined with an unnatural result.

GLAMOUR GLOW

This effect is most commonly used with portrait photographs to add a soft, dreamy glow. It is useful for adding impact to sunsets, too. You can use one of five pre-set glows or create a personalized glow effect and make more precise adjustments to these pre-sets by altering the Glow, Saturation, and Warmth levels.

DRAMA

Drama applies six different pre-set filters, from subtle adjustments through to wild artistic effects, to boost the details in an image if they look a little flat. The filters include **Drama 1**, **Drama 2**, **Bright 1**, **Bright 2**, **Dark 1**, and **Dark 2**.

The Filter Strength and Saturation of each of the six pre-sets can be enhanced. The effect works by adding a degree of grain and contrast, and is best used for urban or landscape images, especially where there are strong weather elements such as clouds.

In this example the filter has been set to 90% so you can see it, but in general the effect is very destructive, so keep it at under 20%, perhaps even under 10%, and go to the Layers stack to mask the edit in some of the appropriate areas (such as the sky) rather than letting it affect the entire image.

VINTAGE

Vintage produces photos that have a nostalgic look with the option to apply 12 different color styles and then make adjustments to the Brightness, Saturation, Style Strength, and Vignette Strength. The pre-set options are numbered **1** to **12** along the bottom of the screen.

GRAINY FILM

Grainy Film gives photos a realistic grain effect, similar to a color film image. There are 18 pre-sets, such as **L05** and **X03**, and both the grain and strength of all of these can be adjusted. The pre-sets are located at the bottom of the screen.

RETROLUX

Retrolux applies light leaks, scratches, and film styles to give photos a strong retro feel. Select from 13 pre-sets and then make adjustments to the **Brightness**, **Contrast**, **Style Strength**, **Scratches**, and **Light leaks**.

GRUNGE

Grunge plays with 1,500 variations of color and texture which are used to create (and later save) individual styles. This is done by adjusting the **Style**, **Brightness**, **Contrast**, **Saturation**, and **Texture Strength**. The focus point of the filter can also be changed by dragging the blue node around the image.

BLACK & WHITE

Black & White can be used to apply color filters as well as create a classic black-and-white image. When some colors are converted to grayscale they look very similar and cause the black-and-white image to look flat and lacking in definition as the objects blend into each other.

The colored lens filters are accessed by selecting the black circle on the left of the bottom menu. They give you control over the way the original colors appear in the black-and-white image, which in turn increases their definition.

As well as the color filters there are also six different black-and-white style features to choose from and you can also adjust the Contrast, Brightness, and Grain of these.

NOIR

Noir creates a moody, cinematic feel, with toning and wash effects producing a look that's evocative of darkroom photography. As for the other filters, you can choose from numerous pre-sets, such as **S01** and **S02**, and then adjust these to create your own personalized filter.

ADDING TEXT

The capacity to include text elements on your image isn't strictly a filter, but it is possible to do. You have the option to change the opacity of the text, invert the text and the image, and alter the design, font, and colors. The **Text** feature is accessed via the **Tools** menu.

ADDING FRAMES

Frames creates stylized borders that sit on top of images, which means they don't affect the final image size or resolution. It might be necessary to crop an image before applying a frame, so no important details are lost. The **Frames** feature is accessed via the **Tools** menu.

There are 23 different frames to choose from (located along the bottom of the screen) and the width of these can be increased or decreased.

The following filters are covered in more detail in the following pages.

LENS BLUR

The Lens Blur filter mimics the swings and tilts achieved in large format photography. In doing so, it creates blur and draws attention to the subject images. See pages 85–87 for a more in-depth overview of how to use the Lens Blur filter.

PORTRAIT TOOL

The **Portrait** option is more of a tool than a filter and can be used to enhance facial characteristics, such as Skin Tone, Eye Clarity, Face Spotlight, and Skin Smoothness in portraits.

See pages 88–90 for a more in-depth overview of how to use the **Portrait** tool.

HEAD POSE TOOL

As the name suggests, you can use the **Head pose** tool to alter the position of a subject's head or gaze.

See page 91 for more on the **Head pose** tool.

DOUBLE EXPOSURE

The Double Exposure filter allows one image to be superimposed onto another. It can be used in practical ways, as in *Case Study 3 Composite with Double Exposure* (see page 104), which demonstrates a sky replacement using this filter.

The filter can also be used in more artistic ways, as demonstrated in *Case Study 6 Double Exposure Recolor* (see page 111).

You can use this filter in many different ways and there is lots of experimentation to be done here. The key to creating a strong Double Exposure image is to use a neutral background with a silhouette and a contrasting foreground.

LENS BLUR TOOL

The **Lens Blur** tool is great for emulating that much sought-after Bokeh background effect and the sort of tilt and swing effects usually achieved with a large-format camera lens system.

Blur is also a useful device for separating background from foreground. This can be used to great effect for product photography or still-life work to create a more 3D effect and to highlight and separate the subject from its surroundings.

There are linear and elliptical effects within the tool, which can be used in the following ways:

• Toggle between the icons in the bottom left to switch from **linear** (**A**) to **radial** (**B**) elliptical effects.

• Use the **Swatches** icon (**C**) to change the way the bright points of light in the blurred areas are shaped.

• Move the center of the protected area by tapping on the blue dot and dragging it around the screen.

• Adjust the size, rotation, and shape of the effect with a pinching gesture on the screen.

You can slide up or down the screen, or use the **Sliders** icon to reveal the following menu options:

BLUR STRENGTH This affects how out of focus the selected area will be. Swipe left or right to increase or decrease the intensity of the effect.

TRANSITION This is the middle line or zone which shows how hard or soft the transition from blur to focus will be. Swipe left or right to increase or decrease the intensity of the effect.

VIGNETTE STRENGTH This works best for circular effects to add a bit of extra impact and atmosphere with light and shade.

ELLIPTICAL BLUR A good tool for portraits and nature shots because it draws attention to the focus, mirroring a classic shallow depth of field.

LINEAR BLUR This is good for architectural and urban photos and gives the tilt shift miniaturization effect. For more about this tool, see *Case Study 4 Tilt Shift Effect* on page 106.

PRECISION DEFINING THE BLUR EFFECT

Sometimes the subject doesn't fit comfortably into a linear or elliptical blur mask. As a result, the blur effect fails to define the subject shape perfectly and needs to be improved through tweaking. Here is a method for defining the blur effect more precisely.

1 In the **Tools** section, select Lens Blur.

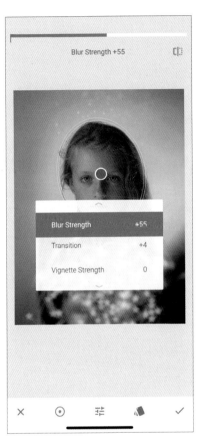

2 A lens blur effect is applied to everywhere in the image except for the face, using the **elliptical blur** tool set to a Blur Strength of +55. Set the Transition to a very small amount of +4 and the Vignette Strength to 0.

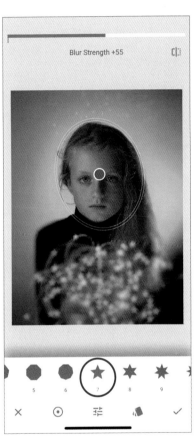

3 Selecting the **blur effect number 7** (the five-pointed star in the selection at the bottom of the screen) gives a subtle hint of the points of a star radiating out from the bright light spots.

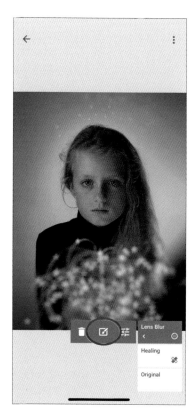

4 Via Edit History on the homepage, open the **Layers** stack for the image, then select the **Lens Blur** layer in the stack. Open the **Brush** tool from the blue fly-out menu on the left.

5 Use the **Brush** tool to mask out the blur effect over the subject's hair and shoulder outline to keep those areas sharp.

6 The blur now only affects the lights above and below the subject's face.

PORTRAIT TOOL

The **Portrait** tool enhances a portrait photo by adding a spotlight effect, which makes eyes sparkle and smooths skin tone. *Case Study 2 Fairy Lights Edit* on page 96 will provide more guidance on portrait editing, while for a bit of fun with headshots, take a look at *Using the Head Pose Tool* in this section.

1 In the **Tools** menu, select Portrait.

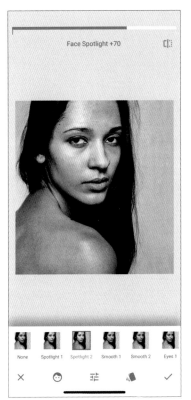

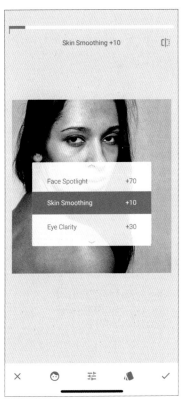

2 The **Portrait** tool opens with a range of pre-sets, such as Spotlight 1 and Smooth 1, from which you can select. Some of these filters target the brightness of the eyes, while others target skin smoothness or skin tone brightness. The Portrait settings can be reset to neutral by selecting None in the same menu.

3 Although the filters apply an adjustment to all three of the edit zones (**Face Spotlight**, **Skin Smoothing**, and **Eye Clarity**), these can be opened up—by swiping up and down on the screen as usual—to reveal the menu and the individual settings can be increased or decreased as desired. The Smooth 2 filter is often a good starting point, but this is subjective and very much dependent on the individual image qualities.

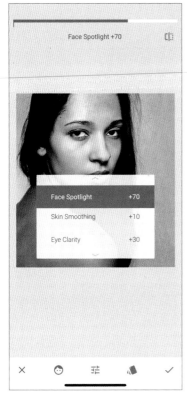

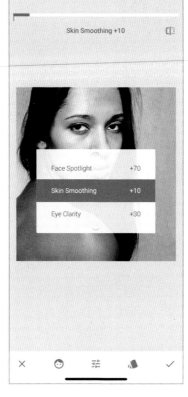

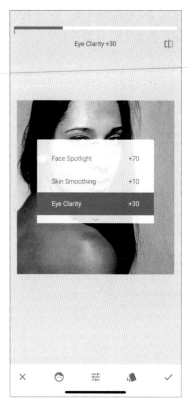

4 Face Spotlight Snapseed auto-detects and brightens the subject's face in the image and darkens the surrounding areas slightly, which has the effect of making a feature of the face in the image. Zoom right in for this one to make sure it is not being overdone—keeping things subtle is key. If the effect can't be done subtly enough, consider using the **Selective** tool set to Brightness to control the area to be lightened more precisely (see page 69).

5 Skin Smoothing This will adjust the subject's skin to make it appear smoother by hiding some of the blemishes. Zoom in and out to check you're not overdoing this effect, as it can make the subject look like a plastic doll. If the effect can't be done subtly enough, consider using the **Selective** tool set to Structure to smooth the skin texture with more control (see page 77).

6 Eye Clarity Snapseed auto-detects the subject's eyes and will attempt to give them a bit of sparkle. Drag back from +100 and watch the eyes until the detail is enhanced but not obviously so—this often occurs at around +30 or less. This can be easily visible if overdone, so keep the effect to the bare minimum required. If the effect cannot be done subtly, consider using the **Dodge & Burn** feature of the **Brush** tool to lighten and brighten the eyes with more control (see page 75).

Ensure that edits are kept to a minimum and do not overdo **Skin Smoothing** or **Eye Clarity** because the result will be better if the subject still looks natural.

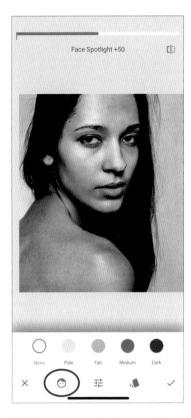

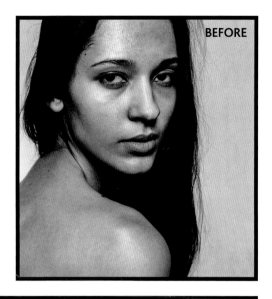

BEFORE

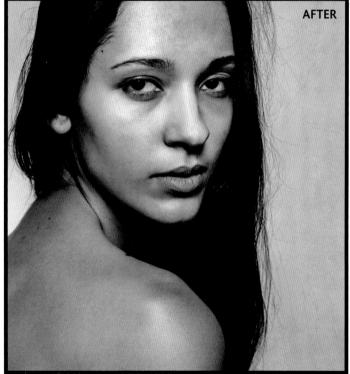

AFTER

7 The icon on the bottom left of the screen that looks like a little face is for assigning a skin tone, with options for **Pale**, **Fair**, **Medium**, and **Dark**. Highlights and bright spots on the face can be adversely affected here, in which case, leave this set to **None** but test the effects on a case-by-case basis to see how it affects each image processed with this tool—it may, for example, work in an image without bright spots and pronounced highlights visible.

USING THE HEAD POSE TOOL

The Head pose tool is a bit of fun. It will make adjustments to the size of pupils, head shape, and so on, and can give images of people or even animals a more humorous or cartoonish appearance.

Choose between increasing or decreasing **Pupil size**, **Smile**, and **Focal length** to open up the eyes, increase someone's smile, or thin or round out the shape of a face. **Head angle** can also be adjusted by moving a face slightly left or right, or up or down. Use the usual pinching motion to zoom in and out to see the changes in detail.

While making very minor adjustments to a portrait using this tool can have its benefits, images can quickly look unnatural. Therefore, perhaps this tool is best left as something fun rather than a serious editing step. It is always better to try and get a good photo rather than fake a smile or change a head angle.

CASE STUDY 1
LIGHT AND SHADE

This picture of a jackdaw was taken from my studio window. The image looked a bit flat, so I decided to subtly increase the light rays and use a vignette to increase the focus on the bird. However, to do this, I developed a far more advanced and sophisticated method of creating a vignette that protects the highlights and creates the light and dark areas in a bespoke shape, as opposed to the uniform circle used by the Vignette tool.

This case study uses the following tools and skills:
- Rotate
- Tune Image
- Layers stack
- Healing
- Tonal Contrast
- Curves
- Masking

1 My first step was to carry out a very minor horizon fix using the **Rotate** tool.

2 Next, I used the **Tune Image** tool to adjust the exposure by increasing the Brightness by a factor of +10 and the Ambiance by a factor of +10 too.

3 The sky then needed masking using the **Layers** stack so that the exposure adjustment would only affect the landscape and not the sky.

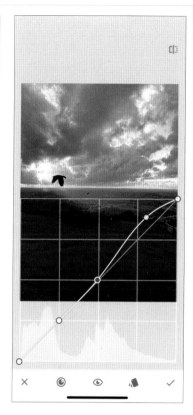

4 I then used the **Healing** tool to remove the blemishes from the grass.

5 Next, I used the **Tonal Contrast** tool to increase the High Tones by a factor of +40, leaving the Mid and Low Tones at a factor of +0.

6 To enhance the light rays from the sun, I applied an RGB **Curves** adjustment layer—placing nodes on the midtones to hold them in place and then raising the high tone part of the curve to increase brightness in just the highlights.

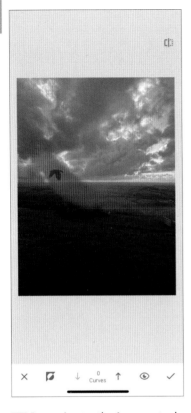

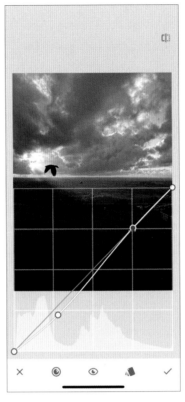

7 Returning to the **Layers** stack, I opened the previous **Curves** layer to access the **Masking** brush. I then used the **Invert Mask** option to invert the mask, so the Curves effect was not visible. I also reintroduced the light with the paintbrush in the same direction and position as the existing light rays with the brush set at 75% Opacity to keep it natural.

8 Next, I created a new vignette with an RGB **Curves** layer and placed a node just below the first intersection but snuggled into the corner. By dragging this node down, I increased the shadows in the image. I then placed a node in the top intersection to hold the highlights in place and protect them in the image.

9 Finally, I masked in the layer in the Edit stack, brushing the outside edge at 25, then moving in toward the center, graduating the steps by 25 at a time (i.e. 50, 75, then 100) to stop the vignette effect being too hard-edged and to make it look more natural.

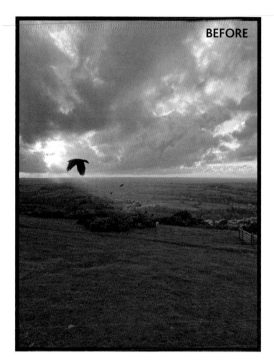

BEFORE

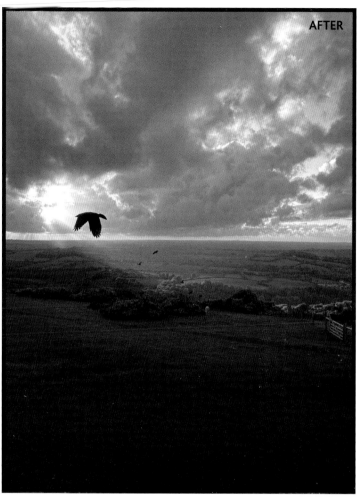

AFTER

10 You can see from the before and after that this is a very subtle change. It is all about creating mood and atmosphere in an image using the lightest of touches.

CASE STUDY 2
FAIRY LIGHTS EDIT

This was mainly an exercise in white balancing for color correction. After an initial assessment of this image (see page 19 for more about image assessment) the main issue to be resolved is the greenish color cast, as the backdrop used was actually more blue than green. This color cast has had an effect on the skin tone, which needed to be returned to a pinker complexion. Much of the heavy lifting in this exercise is done with the **Curves** tool.

This case study uses the following tools and skills:
- Tune Image
- Grainy Film
- Vintage
- Curves
- White Balance
- Brush
- Healing
- Crop
- Interrogating the stack (aka Edit Layer Assessment)
- Masking
- Details

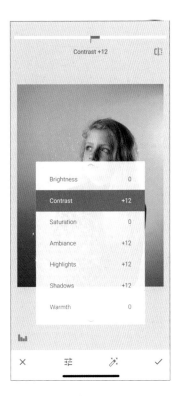

1 First, I used **Tune Image** to increase the Contrast, Ambiance, Highlights, and Shadows by +12 each.

2 Next, I opened **Grainy Film** and started with the X04 filter.

3 I then reduced the Grainy Film from +25 to zero.

4 I opened the **Vintage** menu and reduced the Style Strength to +20 (you reveal the menu by tapping on the Sliders icon or swiping vertically on the screen). I then accepted the changes and exited the tool.

5 Returning to **Grainy Film**, I then selected the X03 filter.

6 I then reduced the Grainy Film to zero.

7 Opening the **Vintage** menu again, I reduced the Style Strength to +20.



CASE STUDIES

CASE STUDIES

CASE STUDIES

CASE STUDIES



CASE STUDIES

CASE STUDIES



CASE STUDIES























CASE STUDIES

CASE STUDIES

CASE STUDIES

CASE STUDIES

CASE STUDIES

CASE STUDIES

CASE STUDIES

CASE STUDIES

CASE STUDIES

CASE STUDIES

CASE STUDIES

CASE STUDIES

CASE STUDIES

CASE STUDIES

CASE STUDIES

CASE STUDIES

CASE STUDIES

CASE STUDIES

CASE STUDIES

CASE STUDIES

CASE STUDIES

CASE STUDIES

CASE STUDIES

CASE STUDIES

CASE STUDIES

CASE STUDIES

CASE STUDIES

CASE STUDIES

CASE STUDIES

CASE STUDIES

CASE STUDIES

CASE STUDIES

CASE STUDIES

CASE STUDIES

CASE STUDIES

CASE STUDIES

CASE STUDIES

CASE STUDIES

CASE STUDIES

CASE STUDIES

CASE STUDIES

CASE STUDIES

CASE STUDIES

CASE STUDIES





CASE STUDIES

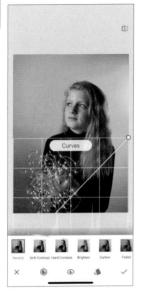
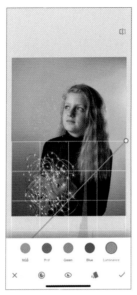

8 I opened **Curves** from the **Tools** menu and selected the Luminance curve.

9 I tapped on the line to create a new node and then dragged this down slightly in the top-right area to darken the highlights. I created another node in the center of the Curve line to brighten the mid-tones. Finally, I added a node to the Curve to darken the shadows.

10 Opening the **Red Curve** next, I placed a node in the lower end of the highlight area, set to hold the curve without an upper or lower adjustment. This was to prevent the whites of the eyes from turning pink. I raised a mid-tone node slightly to add some pink hues. I dragged a node placed in the shadow area down to reduce the red hue slightly here.

98 CASE STUDY 2

11 Next, I opened the **Green Curve**. There was already a lot of green in this image, so I didn't feel the need to do much here. I lowered nodes placed in the highlight and mid-tone areas slightly to reduce the green and allow for clear pink hues. I dragged a node placed in the shadow area up slightly to increase the green hues.

12 Opening the **Blue Curve**, I raised nodes placed in the highlight, mid-tone, and shadow areas to add to the blue hues. This enhanced the pink and blue hues overall while decreasing the yellow and teal hues.

13 Using the **RGB Curve**, which combines all the colors in one curve, I darkened the overall effect by placing nodes in the highlight, mid-tone, and shadow areas and lowering all three.

14 Using the **White Balance** tool, I adjusted the warmth of the **Temperature** very slightly by moving the slider right (away from the cool blues) to +2 to increase the yellows. I increased the Tint by +2 (toward magenta pink) to reduce the green slightly.

15 I used the **Dodge & Burn** brush to dodge (+5) first to lighten the whites of the eyes.

16 I then set the **Dodge & Burn** brush to burn (−10) to brush over the iris and pupil areas of the eyes and burn in slightly, darkening them and making them appear sharper at the same time.

17 I found some of the light spots at this point were distracting, so I used the **Healing** tool to remove a few of the spots from the face area.

18 I then assessed the image and found that some color banding had appeared in the smooth background during the edit. The eyes also needed sharpening, which I would tackle at the very end, using the **Details** tool.

19 First, I cropped the image using the **Crop** tool to remove as much of the banding as possible from the frame.

20 I then opened **Edit History** at the top of the screen to **View edits** (and see the edits that had taken place).

21 In order to discover where within the edit the color banding had appeared, I interrogated the **Layers** stack, turning on each layer one after the other until I identified which layer was causing the banding. A few adjustments were made to minimize its effect.

22 I masked both the Grainy Film layers, but only on the subject to prevent them increasing any banding on the smooth color gradient in the background.

23 Finally, I opened the **Details** menu and made an adjustment using the Sharpening slider, which was increased to +20.

24 I then masked the Details edit layer.

25 I only used the masking for the main subject area to avoid any further banding appearing in the background.

26 In the final image, the skin tone has been corrected, the distractions removed, the eyes look sharper, and the colors are more natural overall.

BEFORE

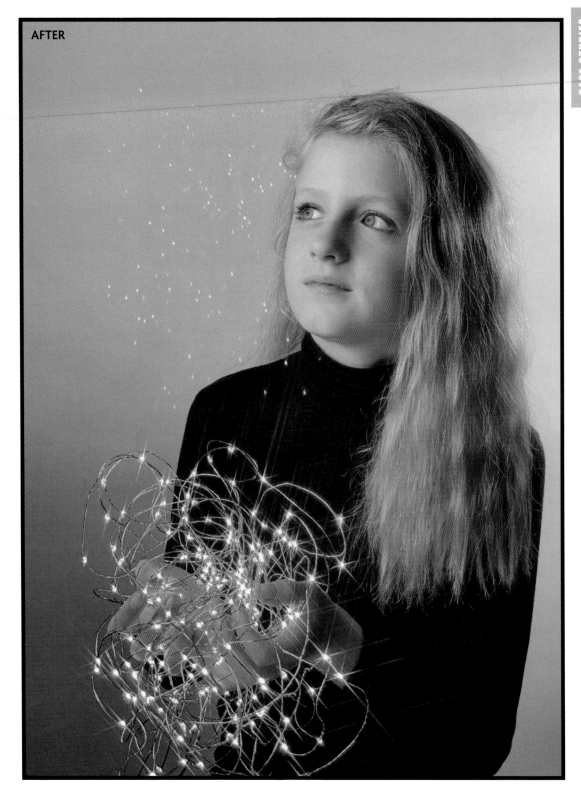

CASE STUDY 3
COMPOSITE WITH DOUBLE EXPOSURE

This is a picture of rural life at Mont Saint-Michel in France, featuring sheep in the foreground. The original image feels a bit flat to me, as Mont Saint-Michel looks so beautiful when all the lights are on. As a result, the image lacks the magical quality that the lights bring. Unfortunately, when the picture was taken Mont Saint-Michel was not lit up. And I wanted to change that. So, I managed to find another image of the castle, with the lights on, and used this to create a composite image with the

Double Exposure tool. This was similar to doing a sky replacement, but I subtly overlaid some lights onto this structure instead to stop it looking so dark and moody and make it a bit magical.

This case study uses the following skills and tools:
- Healing
- Brush
- Double Exposure
- Layers
- Masking

1 To begin, I performed an edit on the base image. There were a few too many sheep in the photo for my liking, so I used the **Healing** tool to remove many of these from the middle ground to tidy up the composition.

2 Next, I used the **Dodge & Burn** brush at +10 strength to make the sheep look a bit brighter. Here, the red overlay on the sheep shows they were selected for highlighting with this brush tool.

3 Here, I have applied a brush stroke of **Exposure** with a large brush size over the sky above the castle to lighten it slightly at a strength of +0.3.

4 Then I used the **Temperature** brush at +5 strength to increase the orange and yellow sunset hues on the horizon line.

5 I used the Saturation brush over the whole sky at a strength of +5 to increase the vibrancy of the colors in the night sky.

6 Next I cleaned up the foreground with the **Healing** tool, then selectively brightened the foreground with the **Selective** tool.

7 Using the **Double Exposure** tool, (accessed on the main Tools menu) I selected my second image (above) and overlaid this on the edited one. I set the Blend mode to lighten and the Opacity fairly high at roughly 90%. See Case Study 6 (page 111) for more on Double Exposure.

AFTER

8 Next, I visited the **Layers** stack and opened the **Double Exposure** layer, selecting the masking tool. I masked off the Double Exposure effect so that none of the second image was visible. Then I painted in just the lit-up areas of the buildings, very subtly round the edges at 50% and at 100% in the middle, so there was a bit of a graduation of the mask edges.

CASE STUDY 4
TILT SHIFT EFFECT

The tilt shift effect recreates a miniaturization esthetic which is usually achieved by the swings and tilts of a large format camera and lens system. Imitating the tilt shift effect is easy to achieve with a little knowledge and the right image. It helps to have an understanding of how the illusion works by defocusing the foreground and background in a linear shape, leaving only the subject in the middle ground in sharp focus. Our brains are programmed to understand this blur as a visual clue to depth of field, and with this narrow depth of field we think we are looking at something close up. So, the effect is that we are looking at a table-top model rather than a full-size scene.

When choosing the most suitable image to use for this effect, bear in mind that the illusion is best achieved with an image shot from a raised vantage point, and ideally one that features not only buildings but also cars and people, as this enhances the impression of miniaturization.

This case study uses the following skills and tools:
• Lens Blur

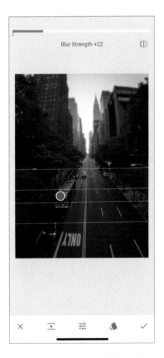

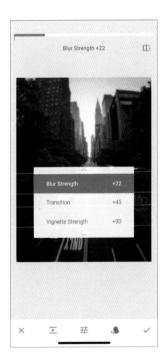

1 With the **linear blur** effect selected, I positioned the blue dot over the bus to denote the middle of the sharp area. I then pinched in the width of the sharp area of the focal plane to form a horizontal narrow band that took in the bus and a few cars in the middle ground.

2 I swiped vertically to reveal the options menu, then set the **Blur Strength** to +22. I set the blurred to sharp **Transition** zone at +45 and the **Vignette Strength** to +30.

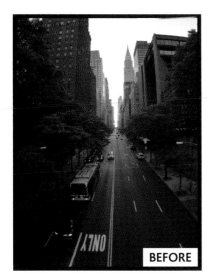

BEFORE

3 Here the tilt shift effect has visibly altered the appearance of scale in the image to give the desirable miniaturization effect of a tilt shift image.

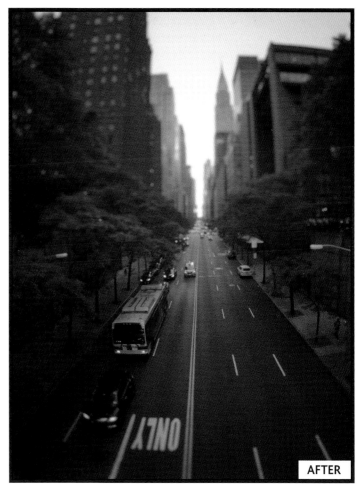

AFTER

CASE STUDY 5
BLACK AND WHITE MISTY CANAL

This image of a misty canal in Exeter, Devon, UK, looked almost monochrome to begin with, as it was shot in early morning light and swirling, thick mist opened up briefly to reveal the rowers and swan.

You can convert a color image to black and white fairly easily. The simplest method for monochrome conversion is to use the **Black & White** tool. Although this does a good job, I prefer to avoid this as it is just a filter effect overlay that will essentially degrade the quality of your image. The degradation is due to the small-pixels dimensions of the filter. Filters like this are designed to be overlaid on images that are only intended for viewing on screen.

A better method for converting a photo into black and white in Snapseed is to use the **Tune Image** tool. Here's how to do this properly—that way, you can create images with a black-and-white style that's unique to you, rather than using the same bolt-on filter that makes one photo look exactly like every other.

This case study uses the following skills and tools:
• Tune Image
• Details
• Interrogating the stack (aka Edit Layer Assessment)

1 First, I opened **Tune Image** in the **Tools** menu.

2 I then selected the **Saturation** option and slid my finger left to reduce the level of saturation to −100. This removed all color from the photo and left me with a black-and-white image.

3 The photo may need some tweaking of the other **Tune Image** menu sliders to bring it alive, especially if it looks a bit flat and gray. I added +44 to the Shadows.

4 I used the **Sharpening** tool in the **Details** menu to increase the sharpness and cut through the haze.

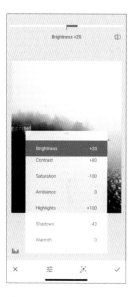

5 I then selected the Structure tool in the **Details** menu and pushed it up to +50.

6 I assessed the image at this stage, and this revealed that the gray sky looked a bit flat.

7 Using the **Tune Image** tool, I raised the Brightness by +20 to give the image more contrast in the sky against the deep black of the water.

8 I revisited the edit layers (via **View edits** in **Edit History**) to fine-tune the darker areas. In the **Tune Image** edit layer, where the Saturation was already at −100, I made the following adjustments to the settings:
Increased the Brightness by +20
Increased the Contrast by +80
Increased the Highlights by +100
Decreased the Shadows by −43.

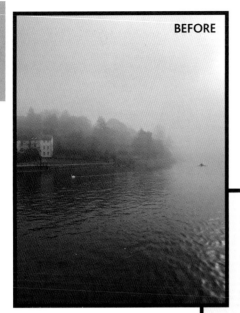

BEFORE

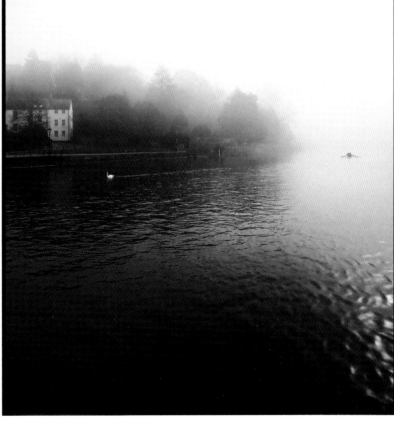

AFTER

9 After editing, the final image now has more depth and atmosphere, thanks to the contrast and richer blacks.

CASE STUDY 6
DOUBLE EXPOSURE RECOLOR

Here is a double exposure of a portrait that would work for either fashion or graphic design projects. This task required some image preparation beforehand to ensure the images sat well with each other. The background also needed to be cleaned up and expanded to allow the images to be resized to overlay each other in a pleasing way.

This case study uses the following tools and skills:
- Tune Image
- Brush
- White Balance
- Curves
- Expand
- Healing
- Rotate
- Save and Export
- Double Exposure

BEFORE (1)

1 To start, I opened the first color image with a plain, light background.

2 I then converted the color image to black and white using the **Tune Image** tool. I opened the menu and adjusted the Saturation to −100. Then I increased the Contrast by +6, the Highlights by +79, and the Shadows by +23 to get a good tonal range across the image.

3 Next, I used the **Brush** tool set to Exposure and set the value to +1.0. Using the brush, I brightened the areas surrounding the subject to make the background nice and clean.

4 Still using the **Brush** tool set to Exposure, I zoomed in close to perfect small details around the gap between the model's body and her arm.

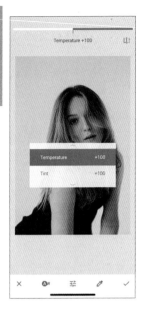

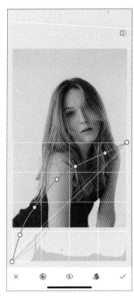

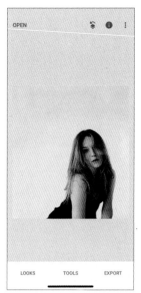

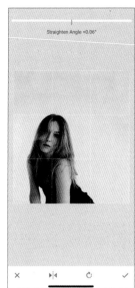

5 Using the **White Balance** tool, I turned the Temperature all the way up to +100 and then did the same for the Tint, turning this up to +100 as well. This made the image look redder in color.

6 I opened the **Curves** layer and activated the red curve. By dragging the red curve up, I made the image redder still. I then selected **Hard Contrast** from the Curves pre-sets to ensure I had strong shadows to work with later when the images were blended together.

7 I needed to expand the area of the image so that when I opened the second image there would be room to reposition the images and still have them sit within the frame. I chose the **Expand** tool and, using **Smart Expansion**, increased the left, right, and top by mimicking pixels in the background area. This created some minor artifacts (repeated patterns, shapes, and content created by expansion) that needed cleaning up using the **Healing** brush.

8 Next, I opened the **Rotate** tool and flipped the image to put the subject's head on the left of the frame rather than the right. This was because in the other image I was going to use, the subject's head was on the right side of the frame. I also adjusted the Straighten Angle to +0.06%.

9 Then I **Saved** and **Exported** this red portrait to use later once I had created my second image.

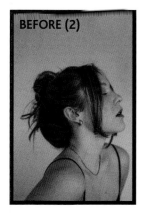

BEFORE (2)

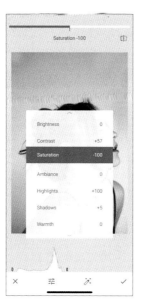

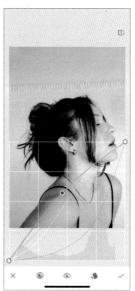

10 I then started again with my second image—another portrait of the same subject but this time facing the right edge of the frame with her face very close to it.

11 I used the **Tune Image** tool to decrease the Saturation by −100 to make it monochrome. I then increased the Contrast by +57, the Highlights by +100 to make the background brighter, and the Shadows by +5.

12 With the **Curves** tool open, I dragged the green curve up and then the red curve down to remove the red and enhance the cyan, which created the turquoise color seen here.

13 I opened the **Expand** tool again and asked it to increase the frame on the left and above and a very small amount on the right-hand side.

14 The Expand tool created a lot of anomalies in the background that needed removing using the **Healing** tool. I used this to remove the unwanted artifacts created by the expansion.

15 I now **Saved** and **Exported** this new turquoise image and reopened the red image that I created in the first stage.

It is important to note that you can only reposition the second image when creating Double Exposures, so make sure you open them in the right order for the image that you want to create.

17 I raised and lowered the **Opacity** until I was happy that 50% opacity worked best for the visibility of both images. Next, I chose to resize the new image, moving my finger and thumb apart to make it substantially larger because I wanted the original image to frame up within the hair area of the second portrait.

16 With this image open I could now open the **Double Exposure** tool (found on the main **Tools** menu) and, using the Double Exposure icon in the menu at the bottom of the screen, I opened my next image, the turquoise one. This created an instant overlay ready for me to edit further to create the desired image.

Opening the Swatch Book on the bottom menu gives different **Blend** mode options. There, the **Blend** mode was automatically set to Default. After exploring Lighten, Darken, Add, Subtract, and Overlay, I decided to revert to the Default blend mode.

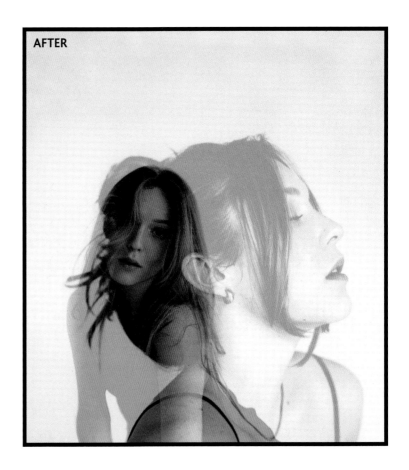

AFTER

CASE STUDY 7
BLACK AND WHITE PONY

Sometimes the texture and detail in an image can be lost in the color. Color can create a sort of blindness to texture and tone. This photo of a pony is a good example of this. By changing the image to a monochrome palette, the texture of the pony's fur and mane is brought to the forefront when viewed in the tonal range from black to white with a rich assortment of grays in between.

This case study uses the following skills and tools:
• Tune Image
• Healing
• Details
• Masking
• Interrogating the stack (aka Edit Layer Assessment)

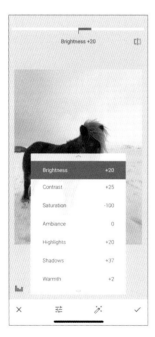

1 After accessing the **Tune Image** menu, I set the Saturation to −100 to make the image black and white. I also used Tune Image to:
Increase the Brightness by +20
Increase the Contrast by +25
Increase the Highlights by +20
Increase the Shadows by +37
Increase the Warmth by +2.

2 Using the **Healing** brush, I then cleaned up some of the foreground snow, but only the darkest areas.

3 I then worked through the **Tune Image** menu again to increase the Brightness to +23 and the Contrast to +53.

4 I accessed **Details** from the **Tools** menu and increased the Structure to +60.

5 I then increased the Structure to +93.

6 I opened the **Masking** brush in the **Details** edit layer and masked in the areas that I wanted to be sharp: the eyes, nostrils, and forehead star.

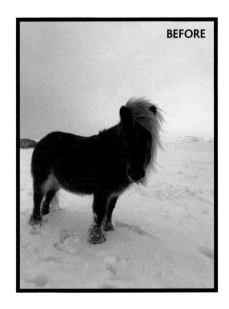

BEFORE

7 For this image, I removed color to draw attention to detail, increased this detail further around the horse's facial features to enhance the impression of sharpness, and cleaned away distractions in the snow to focus the viewer more on the textural detail on the horse. The change in the overall brightness creates a lighter, brighter mood.

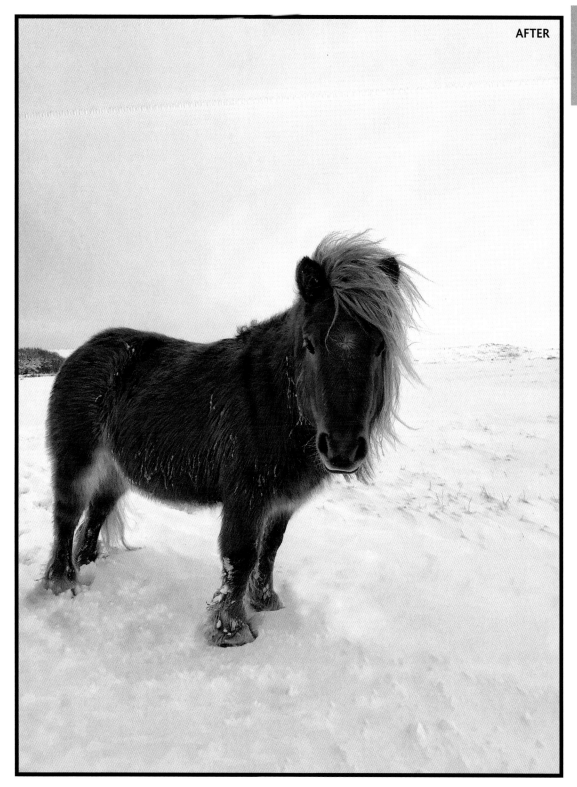

CASE STUDY 8
COLOR POP MASKING

Some people enjoy the visual effect of having pops of color in an otherwise black and white image. This simple exercise will hone your masking skills and show you how easy it is to create a color pop in a few simple steps.

This case study uses the following skills and tools:
- RAW Developing
- Exposure
- Edit History/View edits
- Develop
- Tune Image
- Brush
- Masking

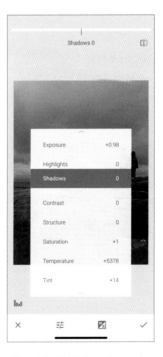

1 **RAW Develop** I selected an image to which I wanted to apply a color-pop effect. You don't need a RAW file to create this effect, but the image to be edited just happened to be one in this case.

2 The file is identified as RAW because the RAW Develop icon is the first one in the top left of the screen when the **Tools** menu is opened.

3 With RAW Develop selected, I tapped the **Sliders** icon at the bottom of the screen to open a menu that revealed the Exposure and other options. The current settings were now visible:
Exposure +0.98
Saturation +1
Temperature +5378
Tint +14.

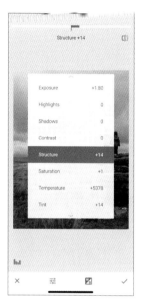

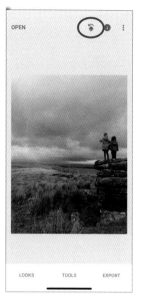

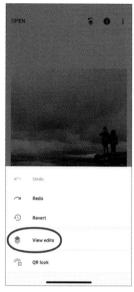

4 I then raised the Exposure to +1.80 and the Structure to +14. Everything else was left as it was. I tapped the **Tick** to accept the changes and exited the RAW Develop area.

5 To make further adjustments to the RAW file, I opened **Edit History** (the stacks icon at the top of the screen) to **View edits** and review them in the **Layers** stack.

6 Here the Develop layer is visible and selected in blue.

7 Tapping the small arrow on the bottom left of the Develop layer reveals a fly-out menu. On the left-hand side of the menu is a Sliders icon which allows access to the previous RAW developments that have been made, so you can revisit and revise them if necessary. On the right-hand side of the flyout menu is an Undo icon (sliders in a circular arrow), which resets all of the RAW developments that have been done.

8 My next step was to make this image black and white. I selected Tune Image from the **Tools** menu.

9 I used the **Sliders** icon at the bottom of the screen to reveal the menu options.

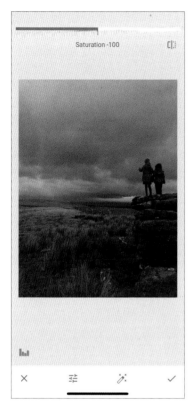

10 In the **Tune Image** menu, I reduced the Saturation to −100, which basically created a black-and-white image, and accepted the change by tapping on the **Tick**.

11 Back in the Home screen, I selected **Edit History** to view the **Layers** stack and mask the black-and-white one. I then selected **View edits**.

12 I then highlighted the Tune Image layer in blue in the Layers stack.

13 I tapped the left arrow to reveal the Flyout menu, then selected the **Brush** tool to create a mask of the black-and-white effect for some of the image only.

14 The image appeared as color again. I painted a rough mask over the figures in the landscape.

15 Zooming in made it easier to see the details. I wasn't concerned at this stage if the selection was not perfectly aligned to the edges, as this could be tidied up later.

16 At this stage, with a rough selection in place, I zoomed out to reveal the overall picture.

17 I used the **Invert Mask** icon in the bottom menu to invert the mask. This inversion meant that everything except the figures was altered by the effect.

18 Zooming in again revealed that the edges needed more attention. As most of the surroundings were already fairly monochrome—since they consisted of black clothing on the bottom half of the children with the rest being gray clouds or rocks—this didn't need to be too accurate. However, I undertook a further tidy.

19 Zooming back out showed a neat separation of the black and white from the colored area. I exited the Layers stack area to return to the Home screen.

20 Finally, the color-pop image was Saved and Exported.

BEFORE

21 The children's colorful coats stand out nicely now against the newly monochrome background. Structure and exposure were increased globally to enhance the landscape.

AFTER

ACKNOWLEDGMENTS

Thanks to Cindy Richards for encouraging me to write another book and the team at CICO Books for helping this book come to fruition. And thanks, as always, to my literary agent, Jane Turnbull for the unwavering support. Enormous thanks to my studio manager Lois Scott AKA Jo Dymond for your endless help with this project and the accompanying playlists that got us through those long writing and editing days.

Thanks of course to my favorite little humans, Kade and Grace, whose very presence in my life inspires me to be the best I can be. Thanks to Mum and Dad for always believing that I can do anything I set my heart and mind to.

Thanks also to Liz Williams at the Royal Photographic Society for encouraging me to write the Snapseed editing workshop that led to this book being conceived. And to all of the people who have attended my workshops in person and online, thank you for letting me road-test my ideas and teaching methods on you!

Last but by no means least, a huge dollop of gratitude to all my nearest and dearest far and wide who encouraged and supported me, helped with childcare, brought me food, drinks, and laughter, and told me to work less and sleep more. I couldn't have done this without you—you know who you are.

PICTURE CREDITS